IMAGES
of America

GLEN COVE

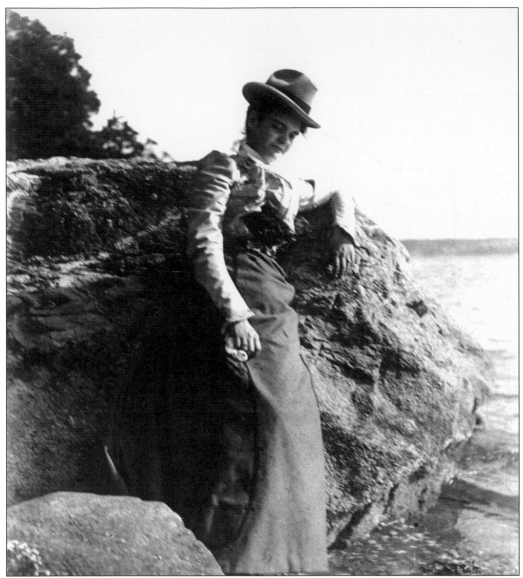

CAROLYN REED COLES, C. 1900. Carolyn Reed Coles (1874–1929), the first librarian in Glen Cove, was married to Franklin A. Coles, a descendant of the original settlers. Their son Robert Reed Coles was director of the Hayden Planetarium and a Glen Cove historian who chronicled the story of the first settlement at Musketa Cove and the development of the city.

On the cover: **FRANCES COX COLES, 1887.** Frances Cox Coles poses for the camera atop her velocipede on Saturday, August 20, 1887. Coles was a descendant of both the Cox and the Coles families, two of the earliest to settle in the Glen Cove area. (Courtesy Robert R. Coles Long Island History Room, Glen Cove Public Library.)

IMAGES
of America

GLEN COVE

Joan Harrison

ARCADIA
PUBLISHING

Published by Arcadia Publishing
Charleston SC, Chicago IL, Portsmouth NH, San Francisco CA

Printed in the United States of America

Library of Congress Catalog Card Number: 2007941862

For all general information contact Arcadia Publishing at:
Telephone 843-853-2070
Fax 843-853-0044
E-mail sales@arcadiapublishing.com
For customer service and orders:
Toll-Free 1-888-313-2665

Visit us on the Internet at www.arcadiapublishing.com

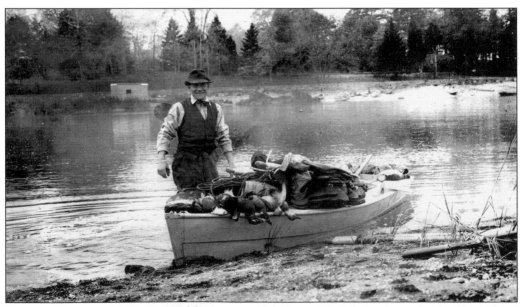

DOSORIS POND, C. 1902. Carl Kohler was a steel and construction inspector for the Long Island Railroad who had a fascination with local history and a strong preservationist instinct. The images he collected, housed in the history room of Glen Cove Public Library, are a valuable archive of old Dosoris and the city of Glen Cove. Here he returns to Dosoris Pond after a duck hunt on Long Island Sound.

GIFT RECEIPT

Barnes & Noble Booksellers #2216
91 Old Country Road
Carle Place, NY 11514
516-741-9850

TR:2216 REG:009 TRN:9472 CSHR:Pat B

len Cove, New York (Ima
 9780738556536 T1
 (1 @ RH.HH) RH.HH G

Thanks for shopping at
Barnes & Noble.

101.16 11/25/2008 10:43AM

purchases made via PayPal. A store credit for the purchase price will be issued for (i) purchases made by check less than 7 days prior to the date of return, (ii) when a gift receipt is presented within 60 days of purchase, (iii) textbooks returned with a receipt within 14 days of purchase, or (iv) original purchase was made through Barnes & Noble.com via PayPal. Opened music/DVDs/audio may not be returned, but can be exchanged only for the same title if defective.

<u>After 14 days or without a sales receipt</u>, returns or exchanges will not be permitted.

Magazines, newspapers, and used books are not returnable. *Product not carried by Barnes & Noble or Barnes & Noble.com will not be accepted for return.*

Policy on receipt may appear in two sections.

Return Policy

<u>With a sales receipt</u>, a full refund in the original form of payment will be issued from any Barnes & Noble store for returns of new and unread books (except textbooks) and unopened music/DVDs/audio made within (i) 14 days of purchase from a Barnes & Noble retail store (except for purchases made by check less than 7 days prior to the date of return) or (ii) 14 days of delivery date for Barnes & Noble.com purchases (except for purchases made via PayPal). A store credit for the purchase price will be issued for (i) purchases made by check less than 7 days prior to the date of return, (ii) when a gift receipt is presented within 60 days of purchase, (iii) textbooks returned with a receipt within 14 days of purchase, or (iv) original purchase was made through Barnes & Noble.com via PayPal. Opened music/DVDs/

CONTENTS

ACKNOWLEDGMENTS

Most gracious thanks go to the board of trustees and staff of the Glen Cove Public Library, in particular to Antonia Petrash, director, and to Carol Stern and Elizabeth Hogan, librarians in the Robert R. Coles Long Island History Room. They unlocked the archives, answered every obscure question with patience, and supported this book with enthusiasm from the very beginning. Major thanks go to a multitude of individuals and institutions, too numerous to list here, who met and shared their lives with me through moving and personal images and stories about this great city. A huge debt is owed to the historians, photographers, and writers who came before, in particular to Robert R. Coles, who I am sure is smiling down on us from his from his own little acre on the moon. Also my sincere gratitude goes to Long Island University, C. W. Post Campus for a sabbatical to research and write this publication; to Landing Pride Civic Association, a tonic for the oldest part of the city; and to my family for their patience and loving support.

Photographs from private collections are credited as such; all other images are from the Robert R. Coles Long Island History Room archives.

INTRODUCTION

Glen Cove, a small city on the north shore of Long Island, traces its origins to a settlement begun on the banks of a marshy creek. Musketa Cove, "Place of the Rushes" as it was known to the Native Americans, had abundant fresh water, verdant hills, and a navigable harbor near New York City. Joseph Carpenter came from Rhode Island in 1668 and found it an ideal place to settle and build a sawmill.

He secured title to the land from the Matinecock sachems, and a little settlement grew. Musketa Cove was not completely isolated, as Oyster Bay to the east had been settled some 15 years earlier, and there were Quaker farms on the outlying lands. In 1677, Carpenter, along with Daniel, Nathaniel, and Robert Coles and Nicholas Simpkins, secured an official patent to "Musketa Cove Plantation" from the British governor, Sir Edmund Andros. Each of the five original proprietors was entitled to a "Home Lott" on the first highway, called the "Place." They were also granted a one-fifth interest in the sawmill and gristmill and an equal portion of tracts of property that included woodland and pasturage. Descendants of these settlers, particularly the Coles family, had a major influence on the development of the city of Glen Cove and continued to live on the Place until the latter part of the 20th century.

The northernmost part of the city, Dosoris, including East and West Islands, also had claim laid to it in 1668 but changed owners several times before it was finally named and settled. The word *Dosoris* comes from a corruption of the Latin *dos uxoris* meaning "wife's dowry." Dosoris was the inheritance of Abigail Taylor Woolsey, who came to settle on it in 1745 with her husband the Reverend Benjamin Woolsey. Together they raised their six children there. Tidal mills were built on Dosoris Creek, and for many years, both Musquito Cove, as the patent came to be known, and Dosoris were rural lands with commerce revolving around milling operations and agriculture.

In 1827, William Weeks left his family farm at Red Spring on the original Carpenter Patent to try his entrepreneurial skills as a businessman. He had a wharf constructed at an area then known as Cape Breton and built the Pavilion Hotel. Soon sloops and schooners were moving goods and produce into and out of the Landing, while the steamboat *Linnaeus* was ferrying city folk to the hotel for country respite. Reportedly an itinerant photographer took the first photograph made in the city at the Pavilion Hotel, a portrait of Thomas Coles and his wife, Amelia.

In 1834, Musquito Cove was renamed Glen Cove to change public perception that it was a place of stinging insects and to bolster the image of the area as a resort. Theatrical and political figures built their homes on the bluffs overlooking the Long Island Sound. W. E. Burton, the famous 19th-century comedian, built the first great estate just to the north of the Landing. John de La Farge, French envoy to the United States, constructed his country manse to the south. A village grew up around the millponds, and a great starch works was built across the

creek from the original settlement. Waves of immigrants flowed into the city to work in the growing industries and to build and staff the magnificent estates that led the area to be called the "Gold Coast."

From 1850 on, photographs tell the story of Glen Cove better than words alone ever could. The more than 200 pictures in the pages of this book describe every aspect of the city from the grand vistas to the key people who shaped its history. The images were chosen through extensive research into family albums and private collections, as well as from the vast photographic archive of the Robert R. Coles History Room in the Glen Cove Public Library. They range from formal compositions taken by professional photographers to snapshots captured by amateurs recording their personal experiences.

The photographs show a hamlet built about millponds turn into a thriving village, and then to an industrial city that never quite lost its rural components. The pictures record the coming of the railroad and trolley, the "cottages" of the Gold Coast and the great steam yachts that plied the waters. They reveal the philanthropic beneficence of the Pratt and Morgan families and the legacy of hard work and strong faith of the Irish, Polish, and Italian immigrants who came to labor and stayed for generations.

The final photographs show the rise of suburbia and the urban renewal that saw the razing of the old city and the beginning of a revitalized waterfront. Framed in these pages are the historical architecture and landscape, parades and groundbreakings, celebrations and sorrows that make up one of the most ethnically and religiously diverse communities in America. If you look carefully, the relentlessly descriptive eye of the camera has also captured a love of place that began more than three centuries ago and still abides in the heart of the Gold Coast.

One

THE PLACE AND DOSORIS

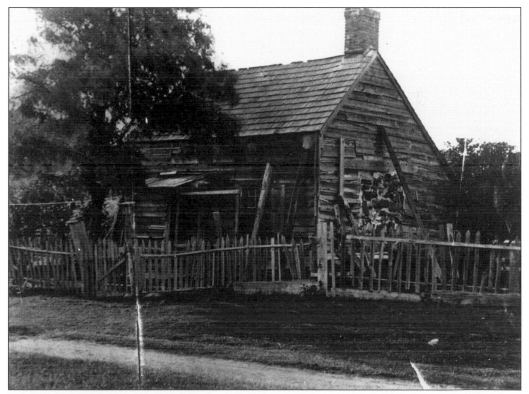

JOSEPH CARPENTER'S HOUSE. The home of the very first settler, Joseph Carpenter, stood on the west side of what is now Dickson Street. The first settlement in the area was known as Musketa Cove, "Place of the Rushes" in the language of the Matinecocks. Each of the five original proprietors received a "Home Lott" on or near the first highway known as the Place, as well as a one-fifth share in the mills.

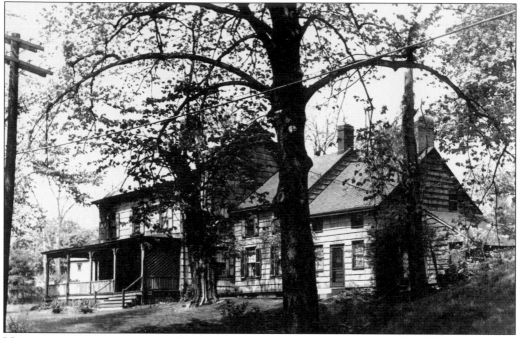

No. 34 the Place, c. 1905. The home of original proprietor Robert Coles still stands on its "Home Lott" on the Place. The original house, to the far right in the image, dates from 1668 and the center addition from 1730. The largest western portion was added before 1800. The brick chimney on this section was purportedly constructed in a spiral design to keep witches and evil spirits out. The house was declared a landmark in 1988.

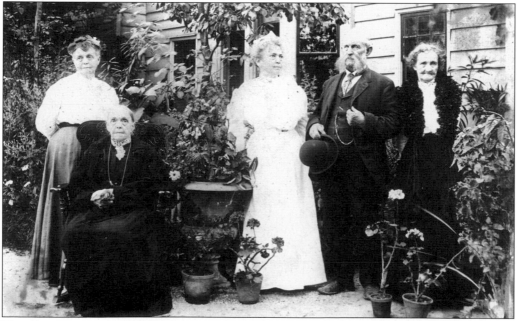

The Coles and the Carpenters, c. 1900. The remaining eldest descendants of the original settlers' families assembled for this early-20th-century photograph. The picture was probably taken on the grounds of Robert Coles's house at 34 the Place.

ISAAC COLES HOUSE, C. 1940. Isaac Coles built this Carpenter Gothic home in 1859, at 7 the Place. Coles left a successful business career to become a surveyor and civil engineer. The home, in nearly mint condition, stayed in the Coles family until the 1980s when it was donated to Old Bethpage Village Restoration. Unfortunately, it was never restored and was allowed to decay there.

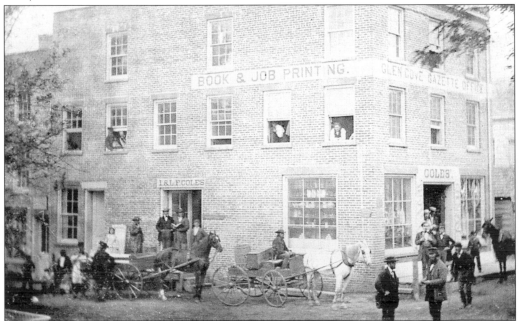

ISAAC COLES'S STORE, C. 1860. This fine tintype shows Coles's mercantile establishment, a well-stocked general store that carried everything from dress patterns and hardware to tobacco and groceries. The building also housed the offices of the *Glen Cove Gazette*, a newspaper established in 1857 as a voice for the Duryea Starch Works. Located on Mill (Pulaski) Street, it was the first three-story brick building in the village.

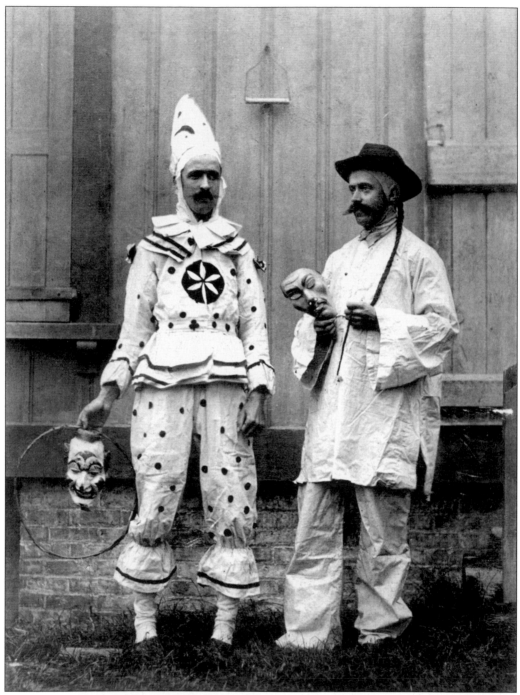

Oscar and Franklin Coles, c. 1900. The social life of old Glen Cove was filled with pageants, dances, and fetes. Oscar (left) and Franklin Coles, sons of Isaac Coles, stand dressed for masquerade at 7 the Place, possibly in preparation for the annual Thanksgiving Day festivities. The yearly celebration included a costume parade, the Ragamuffin Brigade's annual shoot in Barlow's Hollow, and a grand ball.

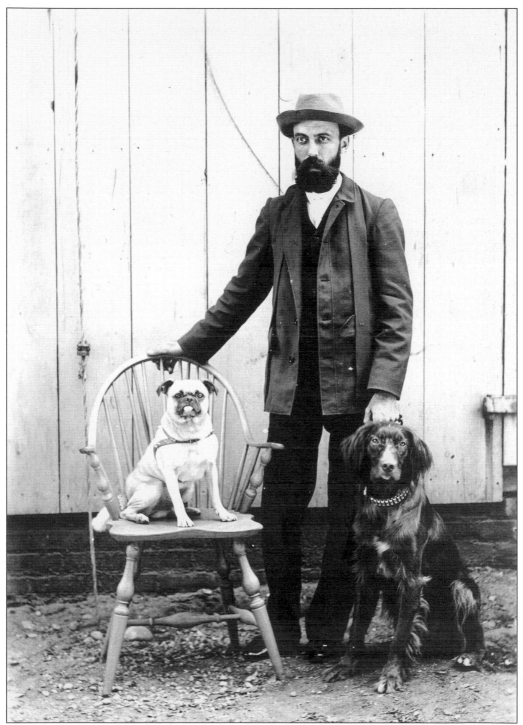

THOMAS COLES, C. 1900. Behind the barn at 7 the Place, the eldest son of Isaac, stands with his pet dogs. After Thomas's death, his widow, Sally Pancoast Coles, lived in the house for many years with other members of the Coles family. She painted china and ceramics and had a kiln on the premises.

SHEEPS PEN POINT. The farm of Joseph, and later Jesse Coles, a patriot spy, was once home to a large herd of sheep. According to local myth, Captain Kidd's treasure was buried there and subsequently unearthed secretly. Then it was dragged, in the dark of night, to the beach and a waiting ship. The area is now Garvies Point Preserve.

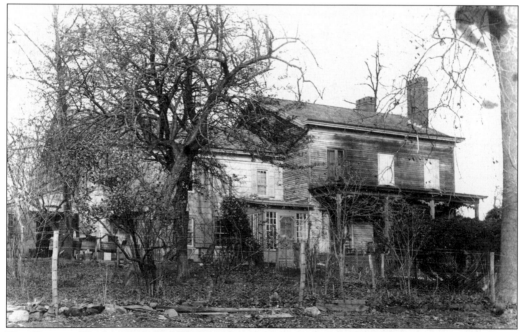

THE GARVIE HOMESTEAD. Dr. Thomas Garvie, born in Scotland in 1775, came to Glen Cove in 1803 and bought Coles's old farm. He established a medical practice and was an astute businessman who negotiated with Cornelius Vanderbilt to build the first steamboat wharf on his shorefront. The wharf, located on the site of what is now the Hempstead Harbour Club, facilitated the exportation of clay from the property.

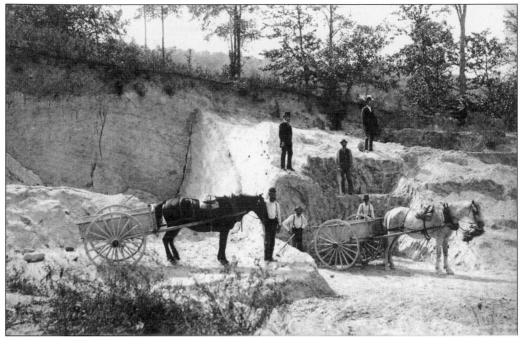

THE CLAY PITS. In 1827, veins of clay were discovered and mined by the Carpenter brothers along the southern shore road. Then in the 1830s, Garvie began mining the clay from the cliffs on Sheeps Pen Point on the north side of the creek. The clay, shipped out by schooner, was used for stoneware, bricks, and the linings of stoves.

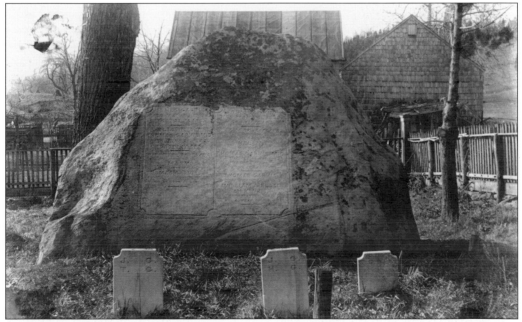

THE GARVIE CEMETERY. A great boulder incised with names and biographical information is the centerpiece of the burial ground of the Garvies and their Mackenzie relatives. The cemetery, located near the site of the old homestead and outbuildings, is situated on a rise above the creek in Garvies Point Preserve.

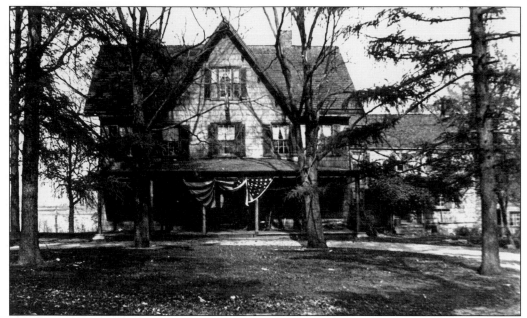

THE WOOLSEY HOUSE, 1890s. The homestead of Rev. Benjamin Woolsey, his wife, Abigail Taylor Woolsey, and their six children was built in Dosoris around 1745. The property was part of Abigail's inheritance of 1,000 acres in the northern part of the region that became Glen Cove. The name Dosoris is a corruption of the Latin, *Dos Uxoris*, meaning "wife's dowry." In the 1850s, the part of the property containing the house passed into the hands of George James Price. The building was razed in 1940.

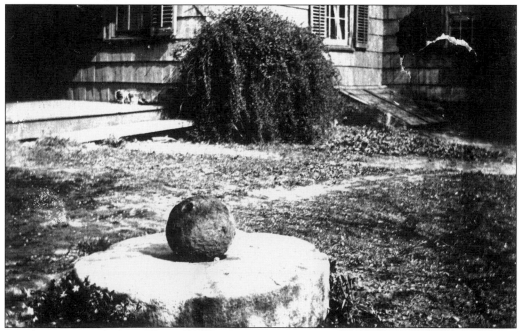

THE MILLSTONE, 1890s. The original millstone, worn out in duty at Dosoris Mill, rested in the dooryard by the kitchen wing of the Woolsey house. The dummy bombshell on top was shot into a Dosoris field as a friendly salute from a Union frigate passing on Long Island Sound.

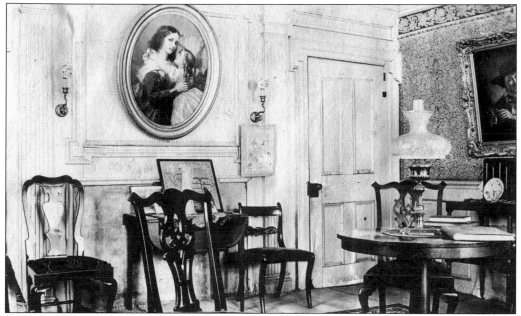

PARLOR OF THE WOOLSEY HOMESTEAD, C. 1890. This parlor view of the Woolscy House dates from the time period of the Price family's ownership. *Just in Tune*, a painting by William Sidney Mount, renowned American genre painter of Setauket, can be seen to the extreme right in the picture.

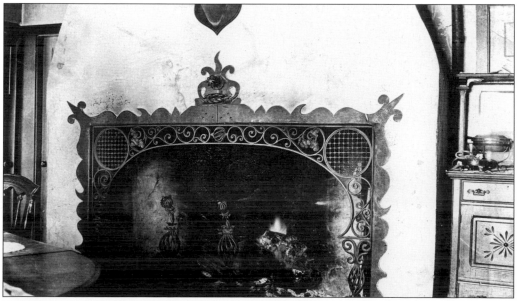

FIREPLACE IN THE WOOLSEY HOMESTEAD, C. 1890. This ornate fireplace decoration was the work of Frank Price. Born in 1852, Price was a structural ironworker by trade who designed the apparatus used to move the obelisk *Cleopatra's Needle* from Egypt to Central Park.

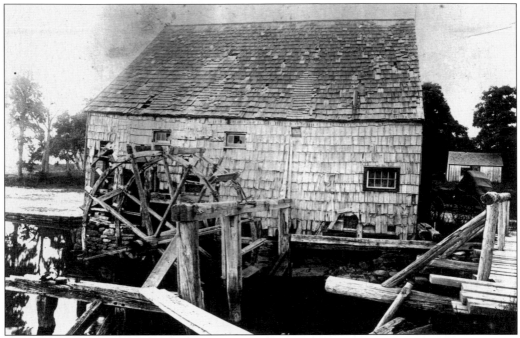

DOSORIS MILL, C. 1880. John Butler, who owned 416 acres in Dosoris, built the first tidal mill on Dosoris Pond around 1760. Later mills were built on the dam between East and West Islands by John Butler Coles and Nathaniel Coles. The last mill remained in operation into the third quarter of the 19th century.

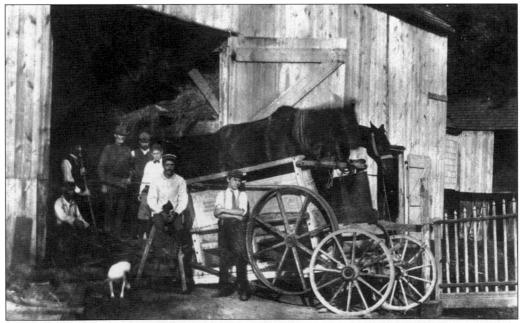

DOSORIS BARNS, C. 1897. Threshing in Dosoris was done during the Price era using equipment from a neighboring farm belonging to Edward Latting. Pictured are, from left to right, Uncle Tom Price, Edward Latting, Edward Cause, several Dosoris farmhands, and a man identified only as a deaf mute.

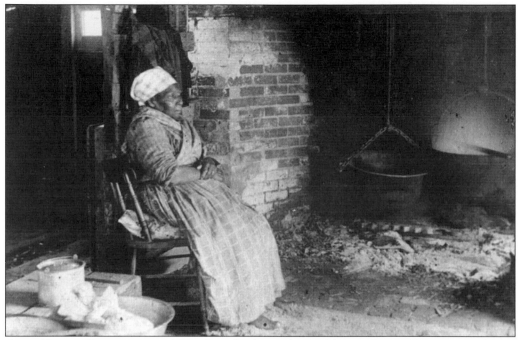

AUNT BETSEY CAUSE, C. 1885. Tending the fire at the washhouse, Betsey Cause, a member of one of the oldest local families of African American heritage, sits by the hearth. The original cast-iron cauldron used for scalding hogs during pig-killing season hangs above the fire. Hogs were slaughtered and used for family consumption into the early 20th century.

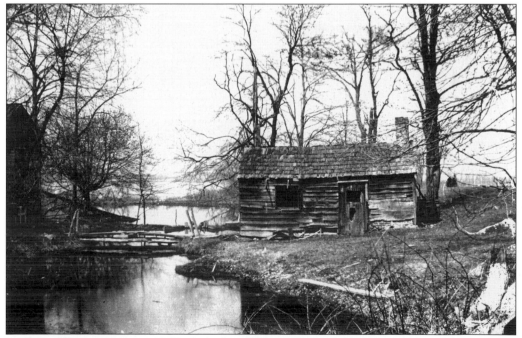

DOSORIS WASHHOUSE, C. 1917. On a hand-drawn map, the Dosoris washhouse is shown to have stood to the northeast of the main house. In later years, the building was used for sorting and canning asparagus grown in the Price family's fields.

THE WOOLSEY CEMETERY. This privately owned cemetery, behind brick walls at the end of Dosoris Lane, contains the graves of generations of the Woolsey family. The stones and remains, moved there from the original estate graveyard, include those of Rev. Benjamin Woolsey and his son Melancthon. Melancthon was Long Island's only casualty in the French and Indian War. A number of gravestones on the site are carved with death angels.

Two

THE LANDING

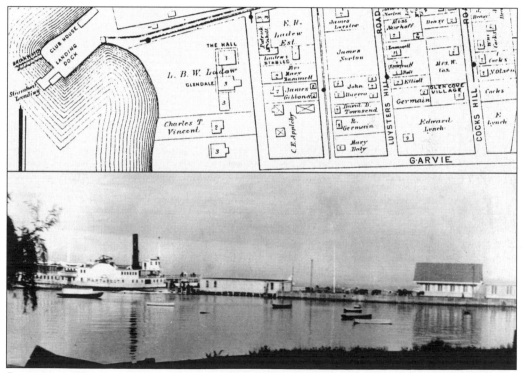

STEAMBOAT DOCK, C. 1903. The original Landing dock was built by William Weeks for the shipping of goods by sloop and schooner. As early as 1829, the steamboat *Linnaeus*, captained by Elijah Peck, stopped at the Landing. Soon after, passenger ferry service was established, and those on holiday found their way to Weeks's newly built Pavilion Hotel. The map shows the location of the dock in relationship to the early waterfront. In the 1890s, Glen Cove was an extremely popular destination and excursions were banned after day-trippers instigated drunken brawls in the local saloons. In 1901, the Long Island Rail Road Company purchased the steamer *Nantasket* and put it on the Glen Cove route. This gave the railroad company control of traffic between all points on Hempstead Harbor and New York City. It also marked the end of the great steamer era.

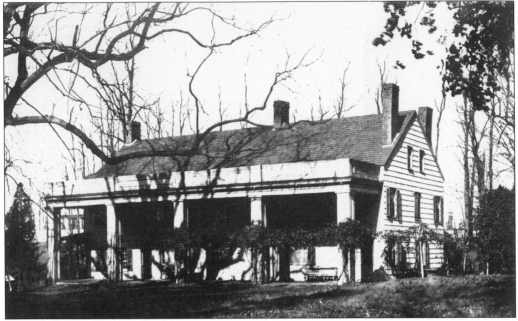

JOHN WEEKS HOUSE, C. 1900. In 1752, John Weeks built a grand homestead on the original Carpenter Patent near Red Spring. It was torn down in 1908 and replaced by the Whitney Estate and John Rogers Maxwell's Maxwellton in what became known as Red Spring Colony. Today the area is called Whitney Circle.

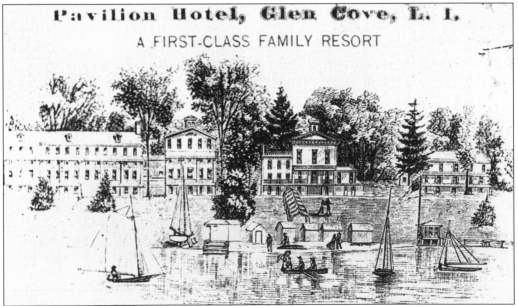

THE PAVILION HOTEL, C. 1877. The first great resort hotel in the Landing was built in 1835 by William Weeks. Weeks left the family farm at Red Spring to become a businessman. He constructed the hotel, owned the steamboat dock, and founded Glen Cove Mutual Insurance Company. The Pavilion, a long two-story inn with a piazza overlooking Long Island Sound, was a favorite resort of theatrical folk from New York City. The building, which stood in the center of what is now Morgan Park, burned in 1880 in a spectacular midday fire.

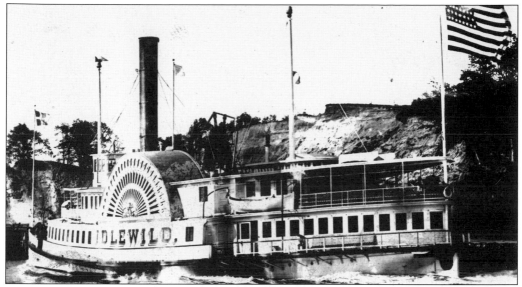

THE *IDLEWILD*, C. 1881. One of the last of the great steamers to provide ferry service to Glen Cove, the *Idlewild*, followed the ill-fated *Seawanhaka*. The latter, which caught fire one terrible day in June 1880, burned off Blackwell's Island, killing upwards of 40 people from the Hempstead Harbor area. Other great steamboats that plied the waters included the *Glen Cove* and the *Long Island*.

THE HALL, C. 1910. After the Pavilion fire, only the ballroom annex, the Hall, was left standing. It was bought by Wright Duryea, head of the starch works, and renovated into his country home, Lindale. Subsequently the Ladews, owners of the leather works, purchased it and leased it to two women who ran it as a hotel. The Hall was demolished in 1928 for the building of Morgan Park, but pieces of it live on in a beautiful home on McLoughlin Street.

SKINNING EELS, C. 1896. Tom Townsend skins eels by the Landing while his friend "Seaman" watches. Eels and clams were harvested from the harbor in great quantities through the 1930s, and the Landing was a popular spot for fishing of all sorts.

SKETCH BOOK VIEW OF THE HARBOR, 1847. Famous landscape painter and ecclesiastical artist John La Farge spent his childhood summers on the family estate in Glen Cove. He made this sketch and many others of the harbor when he was 12 years old. The portrait he painted of himself standing in the family woods, now Garvies Point Preserve, hangs in the Metropolitan Museum of Art.

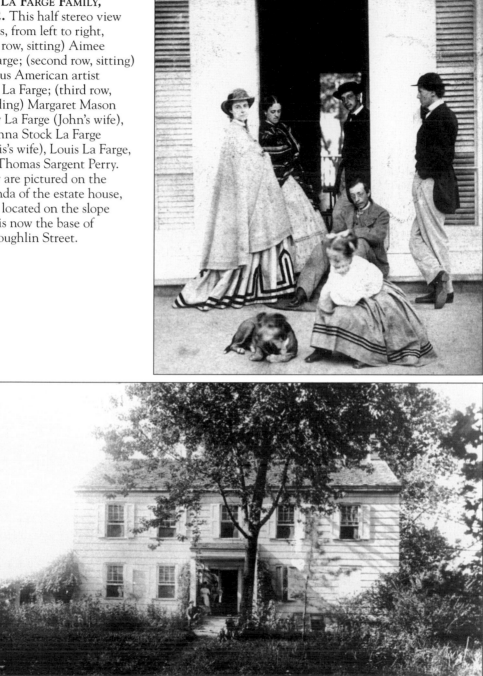

THE LA FARGE FAMILY, 1862. This half stereo view shows, from left to right, (first row, sitting) Aimee La Farge; (second row, sitting) famous American artist John La Farge; (third row, standing) Margaret Mason Perry La Farge (John's wife), Julianna Stock La Farge (Louis's wife), Louis La Farge, and Thomas Sargent Perry. They are pictured on the veranda of the estate house, once located on the slope that is now the base of McLoughlin Street.

THE APPLEBY HOME, 1890s. In 1857, Charles Edgar Appleby, who made his fortune on the waterfront of Manhattan's West Side, acquired the Garvie property at a foreclosure auction on the steps of the Glen Cove Post Office. He bought the adjoining property from La Farge, French envoy to the United States, and created a large estate. The house was demolished for the building of Morgan Park. Appleby's Woods are now Garvies Point Preserve, but the shoreline is still known as Appleby's Beach.

NEW YORK YACHT CLUB STATION NO. 10, C. 1905. John Baptist and Tommy Thompson sit in front of New York Yacht Club Station No. 10. The Gothic Revival clubhouse of the Morgans and their nautical friends was hauled to Glen Cove by barge in 1904. When Morgan Park was built, the gingerbread-style building, originally constructed in Hoboken in 1844, was moved from the breakwater area to the end of McLoughlin Street. In 1949, it was put on a barge again and moved to Mystic Seaport. It is now in Newport, Rhode Island.

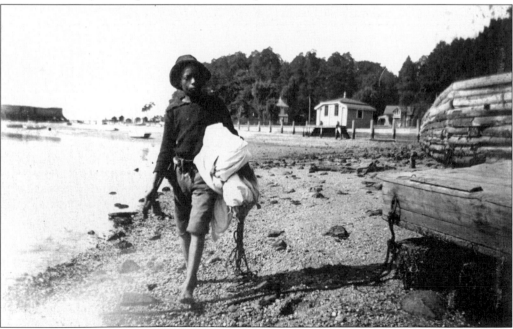

THEODORE FREEZY RUSSEL, 1896. This view looks north as a young man from one of the oldest African American families in the city strolls by the Landing shore. The ferry dock was located to the left, just outside the frame of the photograph. Several African American families in the area can trace their roots back to Colonial times.

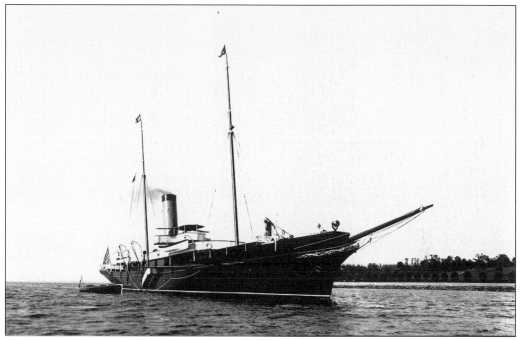

THE STEAM YACHT, C. 1912. The steam yacht *May*, built in Troon, Scotland, for Capt. Joseph DeLamar of Pembroke, was one of the fleet of great ships that filled the harbor from the late 19th century until the start of World War II. The May 31, 1897, edition of the *Brooklyn Daily Eagle* records more than a half dozen of these behemoths laying at anchor including, Edward R. Ladew's *Orienta*, Charles Pratt's *Allegra*, and J. Rogers Maxwell's *Emerald*.

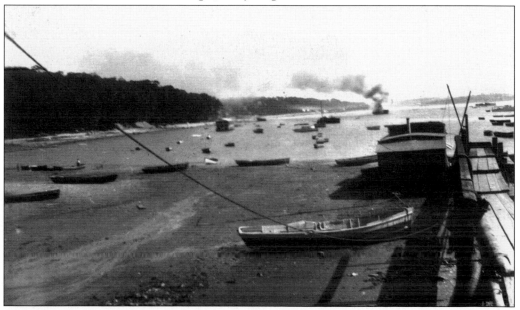

GAS BOAT FIRE, 1927. Leonard Patrick and his bride, Anna, lived aboard their boat that supplied fuel to the great yachts in the harbor. On a Saturday in June 1927, the boat went up in a conflagration that destroyed their home and business. Fortunately, an explosion was avoided, and they escaped with their lives. (Courtesy Edna Patrick Shotwell.)

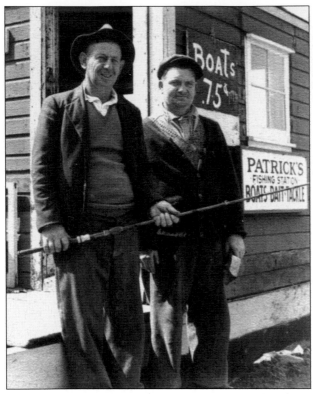

PATRICK'S FISHING STATION, c. 1930. Brothers Lawrence and Alex Patrick stand in front of their boat, bait, and tackle business, which was located near the old Landing. They were born in Shell Cottage on East Island, while their father was a coachman for Leonard Jacob. The fishing station was moved to the end of McLoughlin Street when the park was built and survives to this day in a backyard on Jackson Street. (Courtesy Edna Patrick Shotwell.)

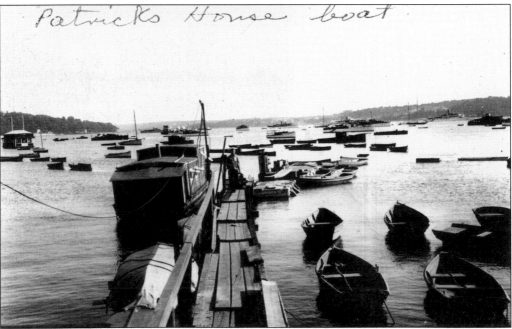

PATRICK'S HOUSEBOAT, 1930. For six years, the Lawrence Patrick family made its home on this houseboat, located on the south side of the dock near the fishing station. As boat rental was a seasonal business, winters were spent in Florida with a community of other Glen Cove "snowbirds." (Courtesy Edna Patrick Shotwell.)

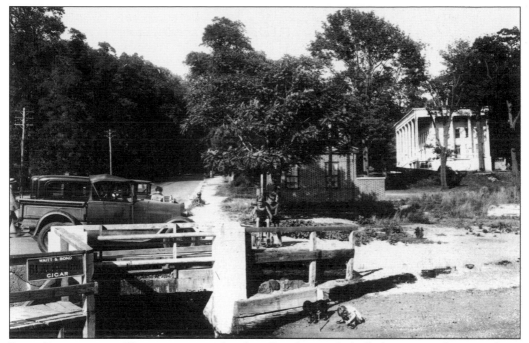

LAST DAYS OF THE HALL, C. 1928. Landing Road extended all the way to the waterfront in 1930. The Hall, soon to be demolished for the building of Morgan Park, can be seen to the right. Edna Patrick and her black spaniel Skipper play on the sand. (Courtesy Edna Patrick Shotwell.)

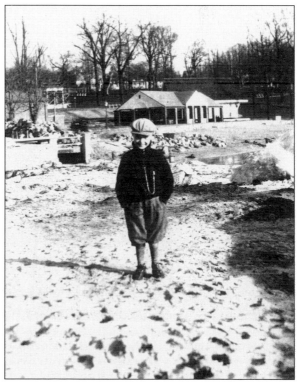

PUMPING SAND, 1930. Demolition and park construction was a major undertaking. Here young Charles Patrick stands by the shore, as sand is pumped in from the harbor to create the swimming beach. One of the brick structures has been completed, and Glen Cove Yacht Station No. 10, behind it, waits to be placed at the southern boundary of the park. (Courtesy Edna Patrick Shotwell.)

29

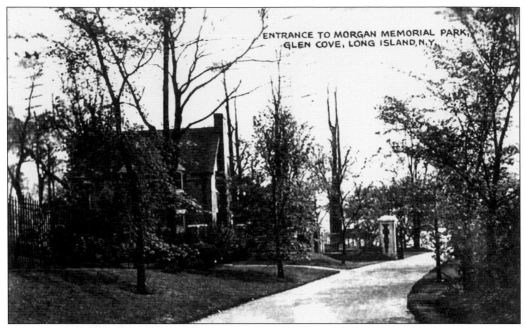

ENTRANCE TO MORGAN MEMORIAL PARK, C. 1932. In 1927, J. P. Morgan Jr. bought property to create a shorefront park in memory of his wife, who died of sleeping sickness in 1925. The Hall, waterfront estates, and cottages south and east of the Landing were leveled for the park construction. The inscription on the gate reads, "In loving memory of Jane Norton Morgan wife of John Pierpont Morgan. This park is provided for the benefit of her friends and neighbors, the inhabitants of Glen Cove and Locust Valley, 1932."

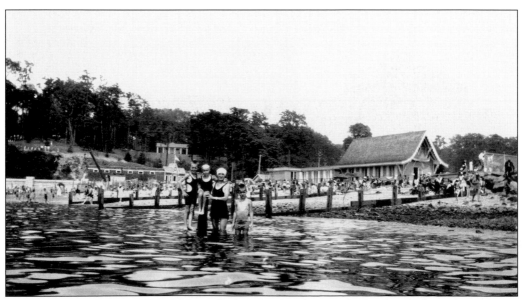

MORGAN PARK OPENS, 1932. Morgan Park opened with great fanfare but without the reclusive "Jack" Morgan at the ceremony. Older people in the village remember Morgan in straw hat and summer suit being driven through the park in an open car by his chauffeur. He asked the children, "How do you like my beach?" (Courtesy Ben Dunne and Brenda Dunne Brett.)

MORGAN PARK LIFEGUARDS, c. 1943–1944. Being a Morgan Park Beach lifeguard was a most desirable summer job. The Morgan Park Beach Lifeguard Crew standing here are, from left to right, Joe Martone, Al Graziose, Gene McManus, Artie Leach, and Bob Gribbin; (sitting on the lifeguard stand) Joseph Palmirotto, Anne Stump, and Eddie Zielazny. (Courtesy Joseph Palmirotto.)

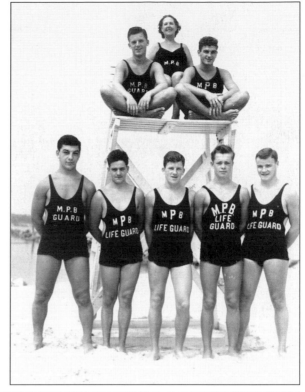

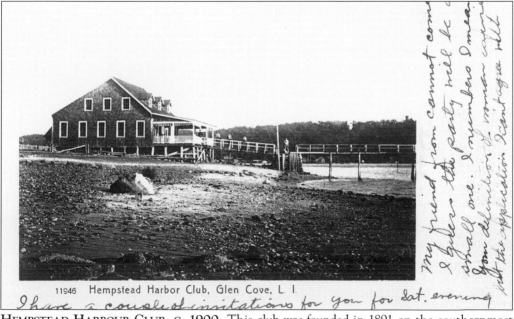

11946 Hempstead Harbor Club, Glen Cove, L. I.

HEMPSTEAD HARBOUR CLUB, c. 1900. This club was founded in 1891 on the southernmost point of the Appleby property. Its regattas, dances, and dinners have been leading social events in the community for over a century. In its heyday, all the prominent families, including the Applebys, Coles, Duryeas, Cocks, and Valentines, were counted among its members. It is still active today with a membership of over 200 families.

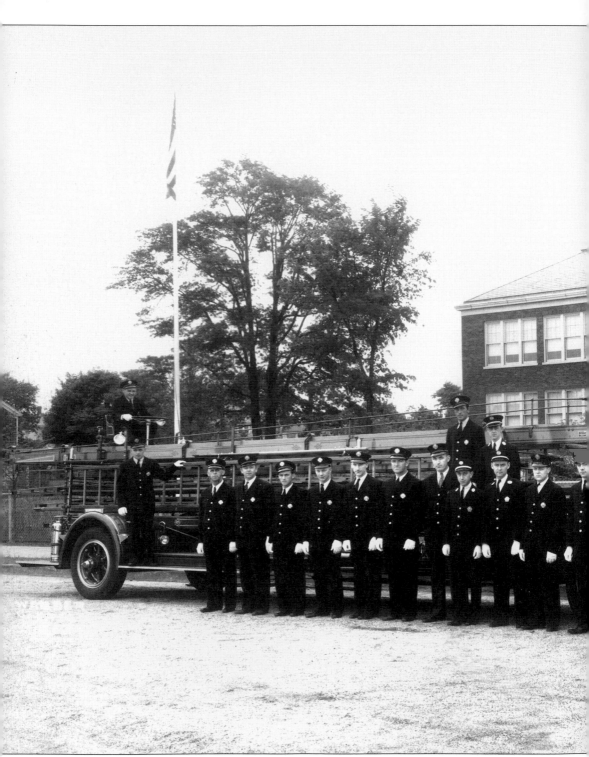

THE FIRE DEPARTMENT AT LANDING SCHOOL, 1933. On Memorial Day, the men of Hook and Ladder Company No. 2 pose in front of Landing School with Glen Cove's first fire dog, Rosie. With the building of Morgan Park, Garvie Avenue was extended to the water and renamed

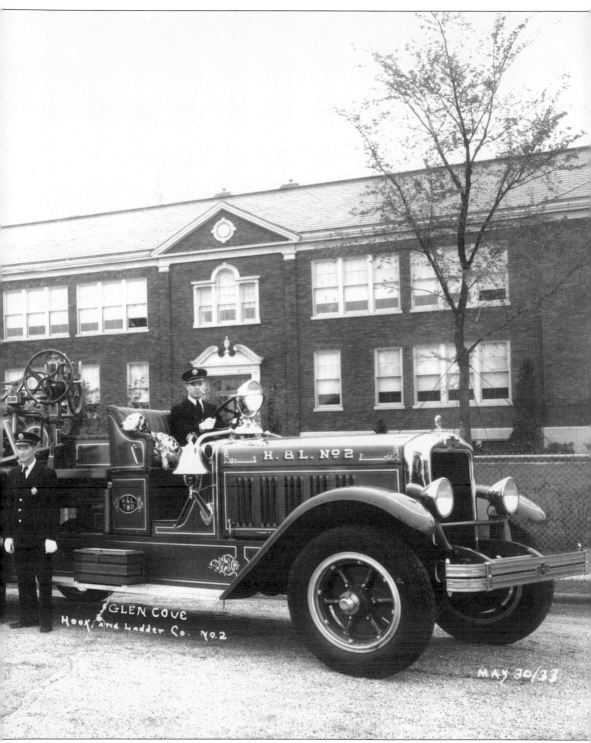

McLoughlin Street. The brand-new Landing School on McLoughlin Street opened the same year as the park. (Courtesy R. Allen Shotwell.)

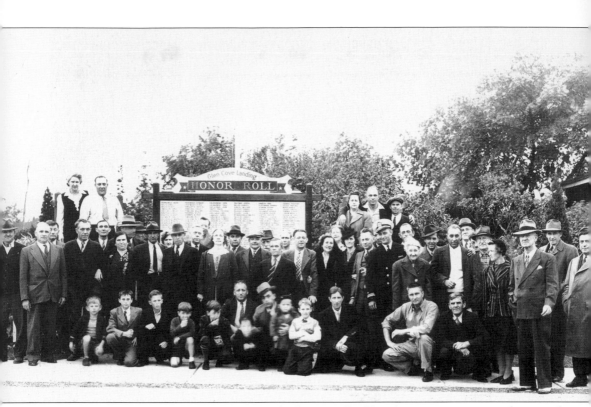

THE LANDING HONOR ROLL, C. 1943. The honor roll of Landing men serving in the armed forces in World War II was posted between Parliman's Store and the Star Tavern on Carpenter Street. Pearl and Joseph Militano, proprietors of the Star Tavern, (left of the honor roll) and Mayor Joseph Stanco (extreme right) can be seen posing with the neighborhood group that turned out for a photograph with the memorial. (Courtesy Flo Cocks.)

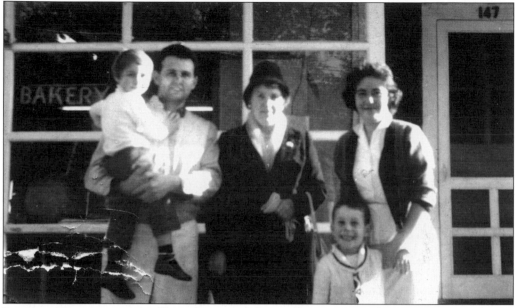

LANDING BAKERY, C. 1962. Henry Kern, with Lisa in his arms, Grandma, and Kevin and Mary Kern stand proudly in front of their home and business. Today Kevin has followed in his father's footsteps as the neighborhood baker. Landing Bakery was an eastern European bakery called the White Eagle before the Kerns owned it and is still known around town as "the Polish Bakery." (Courtesy Kern family.)

RALPH'S DELI, C. 1970. Ralph Cioffi weighs potatoes at his store in the former Valentine Hotel on Carpenter Street. The store was known to have the best candy and the coldest beer in town. The proprietor of the old hotel, Andrew "Shanghai" Wilson, reputedly haunted the room above the store. Today the building is an apartment house. (Courtesy Ralph Cioffi.)

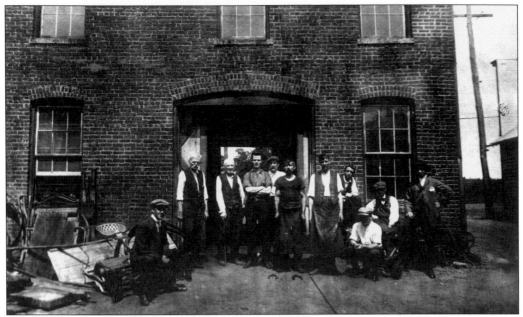

BLACKSMITH SHOP, 1911. F. B. Edmonds Manufactory and General Blacksmithing was located on the corner of Carpenter Street and Landing Road. Here Edmonds (undesignated) poses with his Hungarian blacksmith named Barney, the carriage painter, and the rest of his crew. The building later became a garage and then, with remodeling and a coat of stucco, an apartment building.

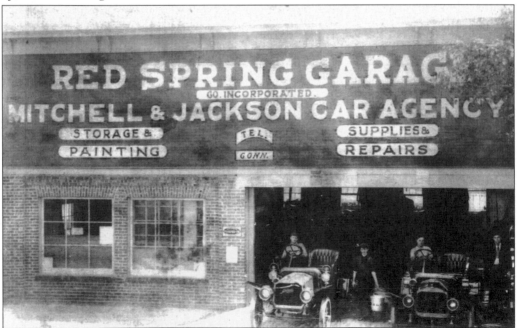

RED SPRING GARAGE, 1920s. The Mitchell and Jackson Car Agency, on Landing Road opposite the entrance to Red Spring Lane, tended to the automotive needs of the Gold Coast. Until recently, Simeone's Classic Cars continued the tradition, refurbishing and restoring vintage automobiles of yesteryear.

Three

STARCH AND LEATHER

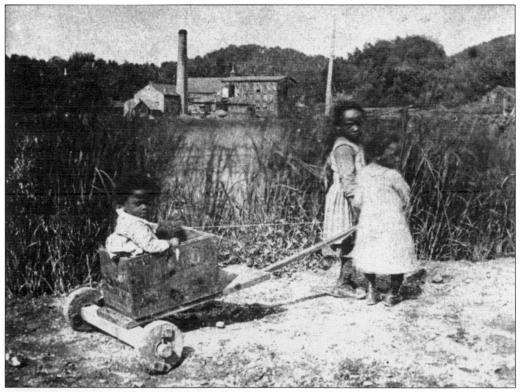

EARLY STARCH WORKS, C. 1860. In the 19th and early 20th centuries, Glen Cove was one of the major manufacturing cities on Long Island. The starch works, followed by a leather belting concern, were its earliest industries. Here local children play in front of the new starch plant. Wright Duryea incorporated the Glen Cove Starch Manufacturing Company in the mid-1800s, drawn by the abundant pure water, local-grown corn, and ease of shipping. When the Duryeas' Oswego plant failed, the rest of the family joined the successful Glen Cove venture. (Courtesy Nassau County Museum, Long Island Studies Institute, Hofstra University.)

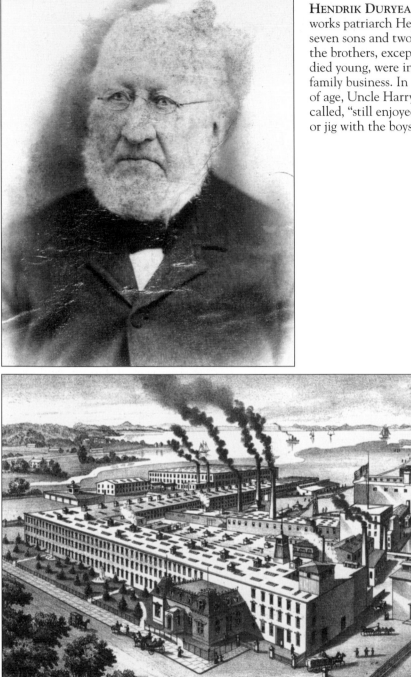

HENDRIK DURYEA, 1880S. Starch works patriarch Hendrik Duryea had seven sons and two daughters. All the brothers, except for Jesse who died young, were involved in the family business. In 1890, at 91 years of age, Uncle Harry, as Hendrik was called, "still enjoyed a double shuffle or jig with the boys."

DURYEA'S GLEN COVE STARCH WORKS. At its height, the starch works covered 30 acres on the south side of Glen Cove creek. It employed 700 workers in its chemical buildings, blacksmith shop, corn elevators, cooperage, box factory, lumberyard, store, printery, and newspaper. Its award-winning products, which included corn starch, Maizena, corn syrup, glucose, corn oil, and soap, were distributed worldwide. These products won medals of excellence in Paris, Vienna, Belgium, Holland, and even the Cape of Good Hope.

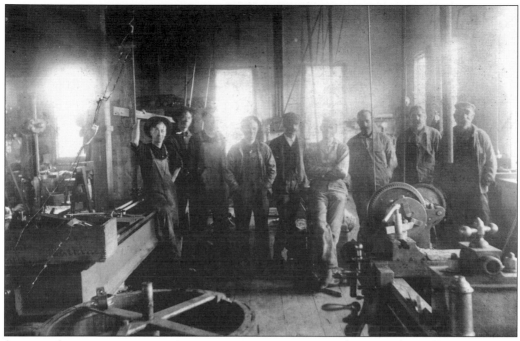

STARCH COMPANY MACHINE CREW, C. 1900. Company workers were housed in tenements. Brick Row was northwest of the lower millpond, and Wooden Row was on Back Road Hill. Living conditions were crowded and unsanitary. From left to right, Tom Duryea (foreman and son of the founder), Joe McCahill, Cuspard Eastman, Jessie Miller, Frank Seaman, superintendent Ed Weeks, two unidentified machinists, and George Campbell (tinsmith) stand in the workplace waiting to go home.

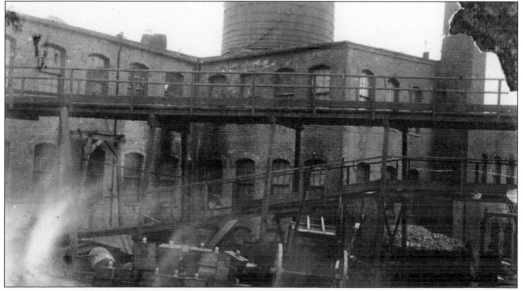

A SMALL CORNER OF THE STARCH WORKS, C. 1900. Conditions in the starch works were dangerous, and fires plagued the factory. By 1879, the stench and fumes from rotting vegetation in the creek were so intense they were reputed to blister paint. Residents of Glen Cove and Sea Cliff petitioned Gov. Grover Cleveland for its closing.

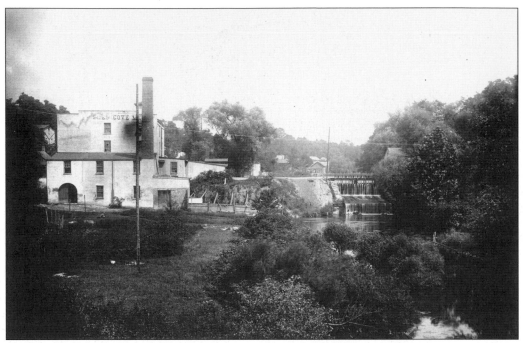

MILL DAM, C. 1890. The millponds, Upper and Lower Glen Lake, were the focal point of the village in early Glen Cove. To the left is Glen Cove Mills. To the right is the old milldam, built about 1775. An advertisement for the mill's flour in an 1877 issue of the *Glen Cove Echo* says, "More in quantity, better quality than any mill on the Island."

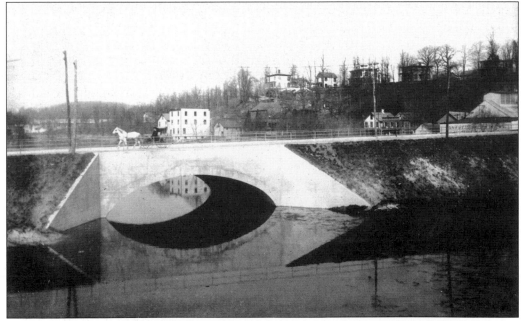

BRIDGE OVER LOWER GLEN LAKE, C. 1906. Originally the only access to south Glen Cove was by footbridge. In 1902, the starch works stopped maintaining the bridge and people climbed the barricades rather than walk all the way around the ponds. Then a bridge for vehicles was built. Today the thoroughfare is still called Bridge Street, although the ponds were filled in long ago.

VIEW FROM MILL HILL, MAY 6, 1906. Mill Hill was originally called Gravel Hill and was owned in 1729 by Josiah Milliken, a periwig maker. This view overlooks the lower milldam and the bridge toward Continental Place. The First Presbyterian Church is located on the hill above the Protective Union Store. The original proprietor's sawmill was near the base of Mill Hill.

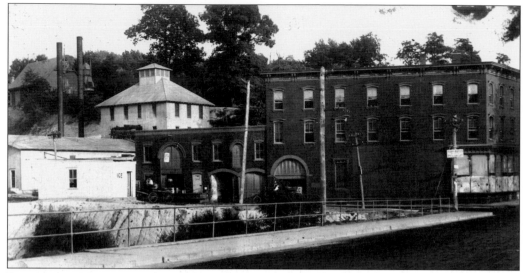

PROTECTIVE UNION STORE C. 1900. In 1878, the starch works built a cooperative store for its employees on the southeast corner of Continental Place and Pratt Boulevard. The Knights of Labor boycotted the store in January 1886 after three workers were discharged. Owner Wright Duryea said he would lose the store before being dictated to. The store carried high-quality goods, and the town children eagerly awaited its Christmas display.

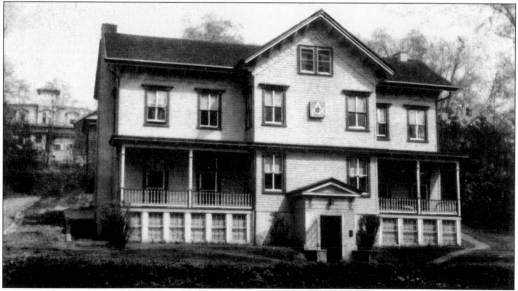

THE MASONIC LODGE. The former home of Edgar Duryea on Continental Place became Glen Cove Lodge No. 580 of the Free and Accepted Masons, chartered on June 11, 1866. Today the Masons meet at the Matinecock Lodge in Oyster Bay. The old house, which housed Community Newspapers for many years, still stands.

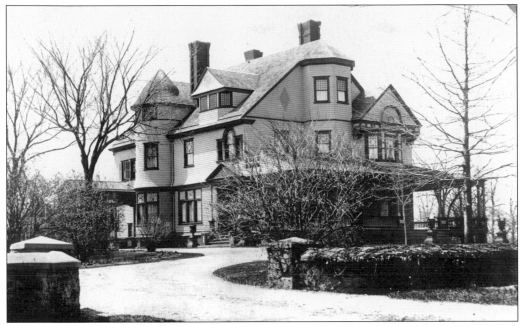

JOHN DURYEA HOUSE, C. 1880. This Queen Anne mansion on top of Robinson's Hill was built for John Duryea in the 1880s. It has Tiffany windows, 24 rooms with chestnut woodwork, and eight fireplaces. This was the longtime family home of Clara Burling Roesch Herdt, an internationally known orchestra conductor who founded the Long Island Singers Society and was the first woman to win a conducting fellowship at the Juilliard School. After her death in 2001, the building was declared a landmark and remains a private residence.

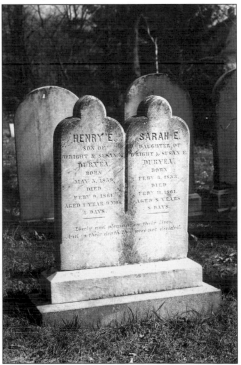

DURYEA TRAGEDY. The gravestones of Henry E. and Sarah E. Duryea stand joined together in St. Paul's churchyard. The children of Wright Duryea, president of the starch works, and his wife, Susan, died two days apart in the winter of 1861. Sarah was just past her eighth birthday, and Henry was not yet two. The inscription on the stone reads, "Lovely and pleasant in their lives, and in their death they were not divided." (Courtesy Michael E. Ach.)

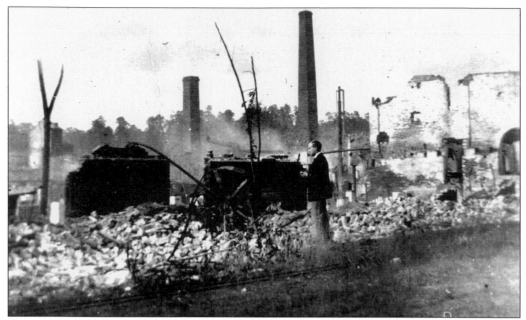

STARCH WORKS RUINS. The starch works had major fires in 1860 and 1898 and was rebuilt after each of them. The *Brooklyn Daily Eagle* records the 1898 fire as being one of the most disastrous ever to take place in Queens County, with two acres of buildings and machinery devastated. After the starch works closed down in 1902, a 1906 fire leveled the entire facility. A historical marker on Glen Cove Avenue commemorates the event.

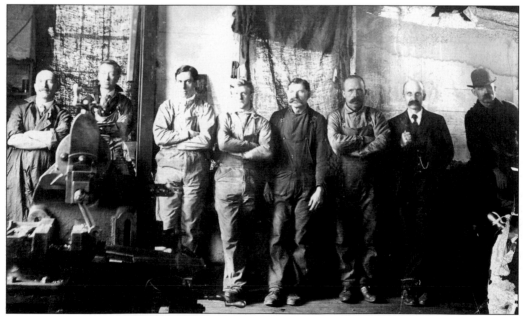

FACTORY CREW, C. 1903. The early factories were run by waterpower and lit by natural light. Work was hard and dangerous, and the hours were long. Skilled laborers like these found employment in the belting works after the closing of the starch factory. Michael J. Donohue took this photograph of his brother Thomas Donohue (fifth man from the left), a steamfitter, and his crew.

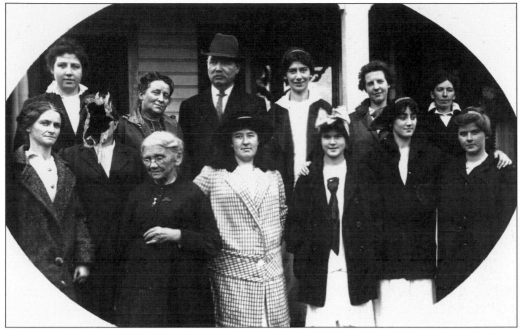

IRISH IMMIGRANTS, C. 1917. Workers in the starch works were mostly immigrants from Ireland. Margaret Erwin Flaherty (front row on the left), born in Ireland in 1840, came from Oswego to Glen Cove with her husband Hugh Flaherty, who worked for the Duryea Starch Works. The matriarch of the Flaherty-Donohue family is shown with friends and family on Crestline, later Donohue Street. The occasion is the leave-taking of Frances Donohue (front row to the right of Margaret Flaherty), who was going off to serve as a yeomanette in the U.S. Navy during World War I. (Courtesy Claire Donohue.)

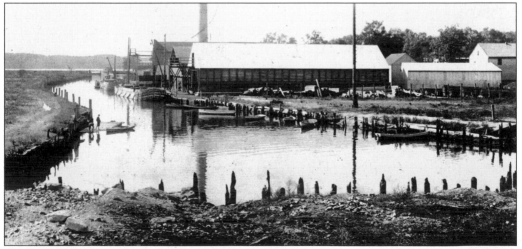

FACTORY CREEK, 1905. In 1903, Fayerweather-Ladew erected a factory to manufacture the belts that ran 19th-century machinery. In 1905, the name was changed to E. R. Ladew and Company. Glen Cove was a company town again, and Ladew became the major employer and the center of social life in Glen Cove. The company had a ball team and a band. It sponsored a summer clambake and a Christmas fete at which every worker received a turkey or $5 and each employee's child was given a present.

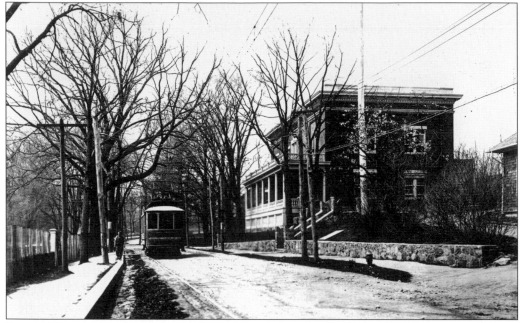

LADEW HEADQUARTERS, C. 1905. The trolley stopped at the Ladew Building on the Place to the east of Robert Coles's house. The building served as the headquarters of the leather works. After the belt factory shut down, the Bobley Publishing Company owned it. In recent years, it was occupied by Konica Minolta, an imaging business that closed in 2007. The building still stands, minus its porch, awaiting its fate as a landmark or victim of the wrecking ball.

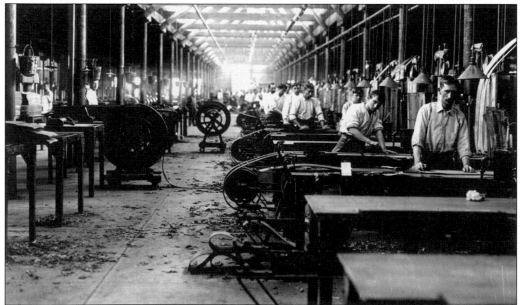

THE FACTORY FLOOR, C. 1905. Inside this facility rawhides were bathed, deloused, cleansed of flesh, stretched, oiled, buffeted, scraped, polished, cut, beveled, cemented, trimmed, inspected, wound, and shipped. At the height of production, the leather works processed 250,000 hides a year and was the largest belt manufacturer in the world. The factory employed 500 people, and the main shop had a larger floor space than Madison Square Garden.

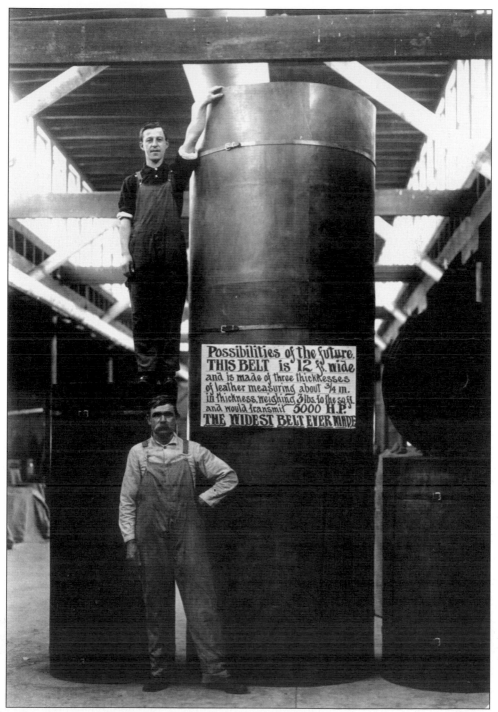

The sign on the belt reads:

Possibilities of the future.
THIS BELT is 12 ft. wide
and is made of three thicknesses
of leather measuring about 3/4 in.
in thickness, weighing 3 lbs. to the sq. ft.
and would transmit 5000 H.P.
THE WIDEST BELT EVER MADE

THE BIG BELT, C. 1905. Ladew leather works produced the widest leather belt ever made. It was 12 feet in width, weighed three pounds per square foot, and could transmit 5,000 units of horsepower. During World War I, the factory produced saddles, harnesses, and other goods for the war effort as well as belts. As leather was expensive, scraps were collected during production and sold to other producers to make consumer goods.

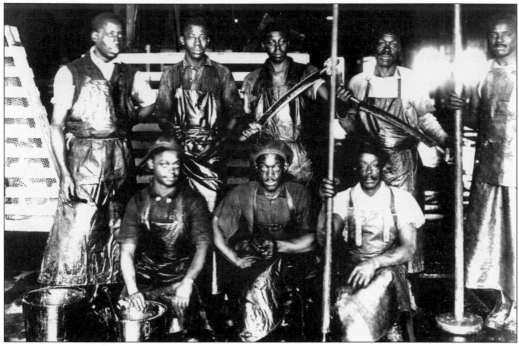

AFRICAN AMERICAN CREW, C. 1910. E. R. Ladew had photographs made documenting the belting factory. The women's crew, the African American crew who pickled the hides, machinists, tanners, and other groups were photographed, as well as the physical plant, including the work halls and infirmary.

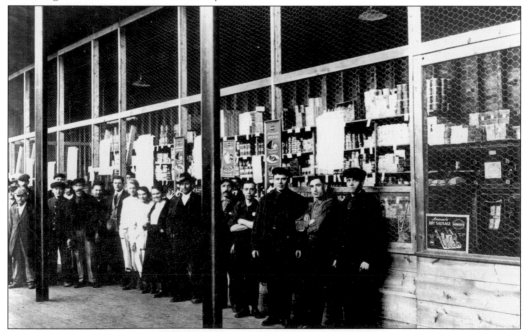

THE COMPANY STORE, C. 1905. Groceries and other quality goods could be purchased at close to wholesale prices on the premises of the plant. The store was a cooperative managed by committee and was popular with the men who had families.

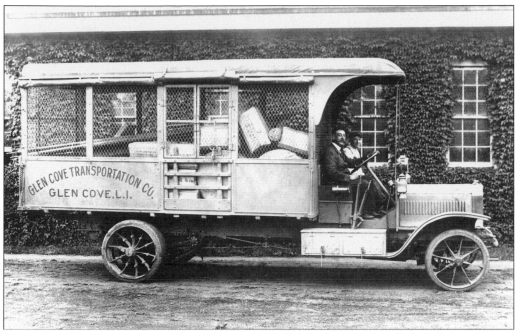

GLEN COVE TRANSPORTATION COMPANY, C. 1905. Rawhides arrived at the belt factory by auto truck, and finished work was shipped out by truck and by barge. Here a Glen Cove Transportation Company truck sits in front of the leather works.

BARGES IN THE CREEK, C. 1905. The leather plant docked the *Rose E. Hanley,* and other barges used for shipping goods, in the creek. The Glen Cove creek was naturally configured and had an island in it until it was dredged and straightened in the 1930s.

FACTORY WHISTLE, 1915. Factory shifts were marked by the sound of this whistle. A July 1915 Sandborn map indicates that the factory whistle on Edward R. Ladew's belt factory also sounded the fire alarm.

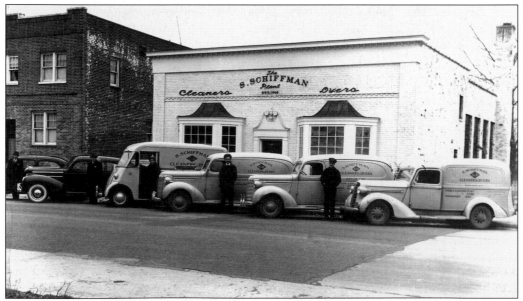

SCHIFFMAN DRY CLEANERS, 1940S. Schiffman's fleet of trucks is lined up before the plant on Glen Cove Avenue, where the starch works once stood. Brothers Sidney and Sam Schiffman moved their dry-cleaning business from Harlem to Glen Cove in the late 1930s and catered to the estate trade. Today the building is Sorenson's Lumberyard. (Courtesy Joanne Mulberg.)

Four

THE GOLD COAST

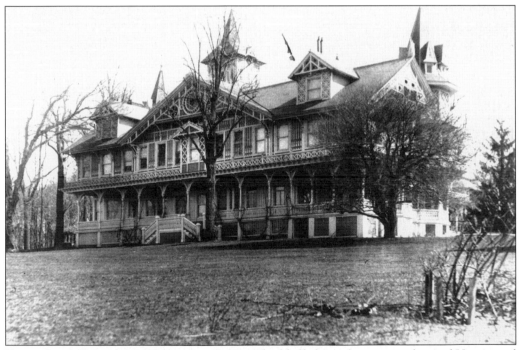

FROM GLEN CHALET TO ELSINORE, 1880s. The bluff along the eastern shore of Hempstead Harbor was a refuge of choice for the financiers and blue bloods of New York society. They flocked from Brooklyn and Manhattan to what became known as the Gold Coast. The first great country estate belonged to W. E. Burton, famous comedian of the 19th-century stage. After his death in 1865, Thomas Kennard owned the property and had the Glen Chalet built by English architect Jacob Wrey Mould. This first high Victorian polychromed and gilt mansion was reputed to glow in the sunset. The next owner, an enormously wealthy railroad lawyer and art collector named S. L. M. Barlow, renamed the estate Elsinore after his daughter Elsie. During the Barlow era, the children of the Landing were given free run of the grounds.

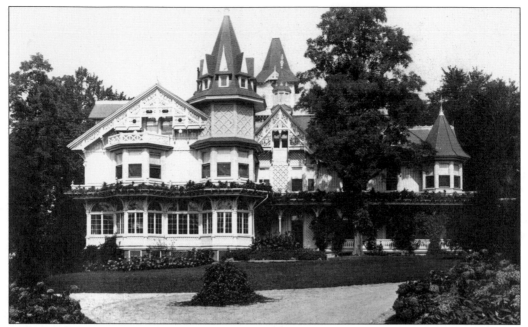

ELSINORE, C. 1905. After S. L. M. Barlow's death in 1893, Gen. James B. Pearsall handled the sale of Elsinore to Edward R. Ladew, owner of the leather works. Ladew enlarged the house, painted it white, and greatly expanded the gardens, greenhouses, and stables. The extravagant doings of the Ladews were recorded in the *Brooklyn Daily Eagle*. Elsinore was shuttered in 1914, after the wedding of Elise Ladew to W. R. Grace. The estate land is now Shorecrest, a housing development built in the 1950s.

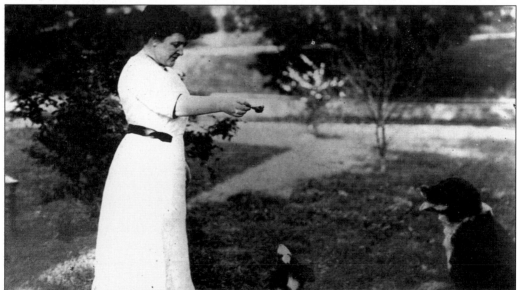

LOUISE LADEW, C. 1905. Louise "Lulu" Ladew, wife of E. R. Ladew, is shown here with her dogs. She was an accomplished horse- and yachtswoman and kept a stable full of high-steppers and trotters. The estate housed a kennel of blooded dogs, a dairy with 28 registered Jersey cows, and a great flock of chickens. The henhouse provided eggs and as many as 100 birds a week to be consumed at Elsinore and on the yacht *Orienta*.

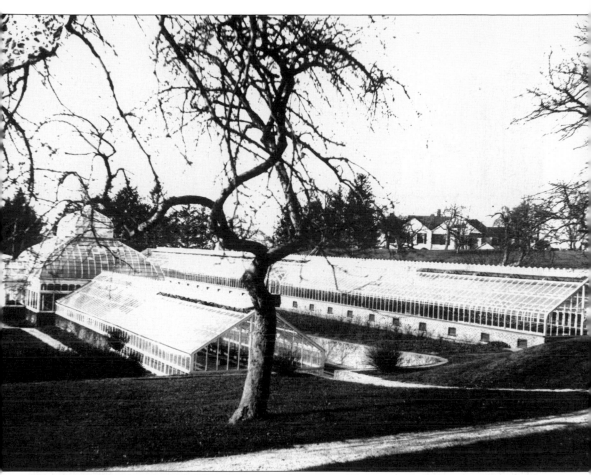

THE GREENHOUSES, C. 1905. The dozen greenhouses on Elsinore included conservatories for roses, orchids, and carnations as well as exotic species like bird of paradise. They contained one of the most complete plant collections in the country. Elsinore's produce took "firsts" in the Queens County Agricultural Fair and at the Waldorf Astoria Flower Show. Beyond the greenhouses were velvet lawns and thick forests of chestnut, oak, hickory, and locust. The Ladew family owned the shorefront from steamboat dock to Pembroke.

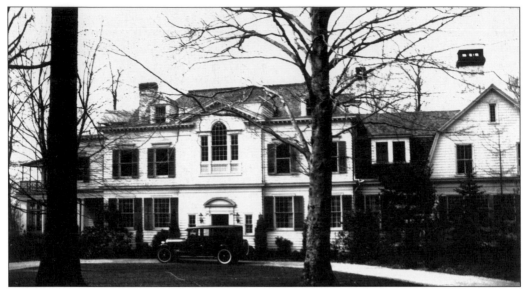

THE HESTER ESTATE, C. 1929. Villa Luedo was built in 1894 just north of Elsinore for Rebecca Ladew, mother of E. R. Ladew, and her other son Joseph. Later it became the country home of Col. William Hester, publisher and president of the *Brooklyn Daily Eagle*. The estate was demolished in the 1980s for the building of Cove Landing. (Courtesy Ben Dunne and Brenda Dunne Brett.)

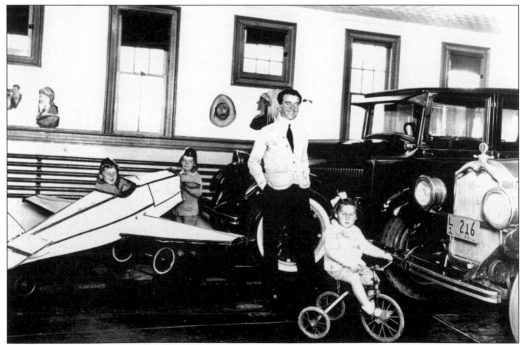

PATRICK DUNNE, THE HESTERS' CHAUFFEUR, C. 1930. Patrick Dunne stands beside a 1926 convertible Buick and a 1929 Cadillac while his boys, Ben, in the toy plane, and Patrick play aviator. His daughter Brenda rides her tricycle. Every Saturday the cars were cleaned with a special ostrich feather duster and the whitewalls were repainted. The Dunne family lived above the garage. (Courtesy Ben Dunne and Brenda Dunne Brett.)

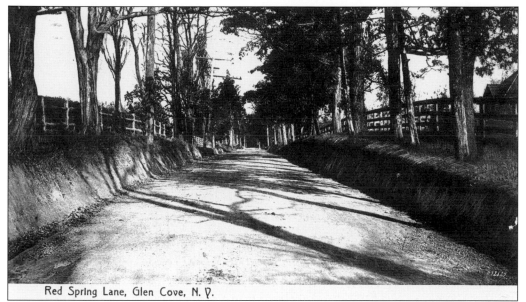

Red Spring Lane, Glen Cove, N. Y.

RED SPRING LANE, C. 1907. Red Spring Lane was laid out in 1713 on the original Carpenter Patent, purchased from the Matinecocks. It extended from Red Spring to Landing (old Cape Breton) Road. The Weeks' property, at the northernmost point of the lane, was developed into the exclusive summer enclave, Red Spring Colony.

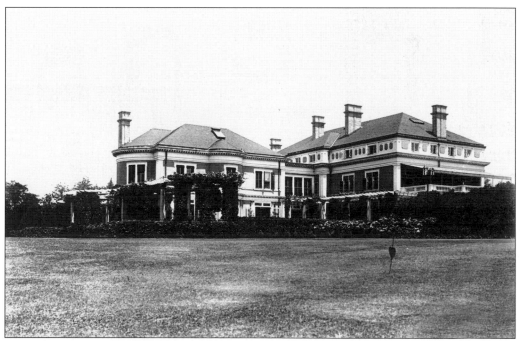

MAXWELLTON, C. 1900. Built in 1898 for J. Rogers Maxwell, president of cement and railroad companies, Maxwellton was one of the most magnificent showplaces on the north shore. Approached through fine gates of stone and iron, this palatial home was surrounded by 27 acres of landscaped gardens and greenhouses. After a fire, the house was razed in 1950. Parts of this estate survive in the properties that now comprise Whitney Circle.

THE PEARSALL HOUSE, C. 1900. The widening of Glen Street and the building of the arterial highway in 1959 brought the demise of the last standing saltbox house built before the Revolutionary War. For 60 years, it was the home of Gen. James Buchanan Pearsall, a politician and direct descendant of Nathaniel Coles, who brokered the real estate deals that created the Gold Coast. The last owners were the Grangers, the first family of dentistry in Glen Cove.

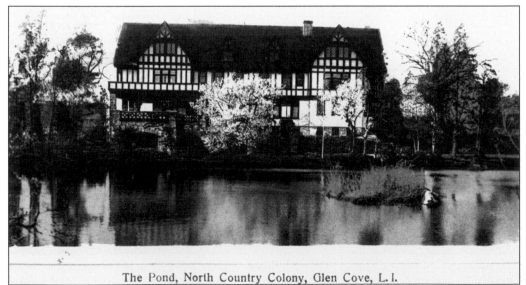

The Pond, North Country Colony, Glen Cove, L. I.

GROENDAK, C. 1911. The Parker B. Handy residence, Groendak, designed by C. P. H. Gilbert, was built overlooking the pond in the exclusive North Country Colony. A prominent industrialist and financier, Handy was one of the founders of the Nassau Country Club.

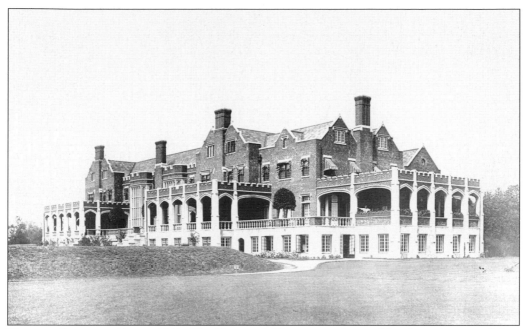

NASSAU COUNTRY CLUB, 1910. The Nassau clubhouse was designed by the architectural firm of Delano and Aldrich and was purposefully sited within walking distance of the Glen Cove train station on St. Andrews Lane. The original golf club, located at Crescent Beach Road and Woolsey Avenue, was known as Queens County Golf Club. It was relocated in 1899, and the name changed to Nassau Country Club. Nassau County was separated from Queens County that year.

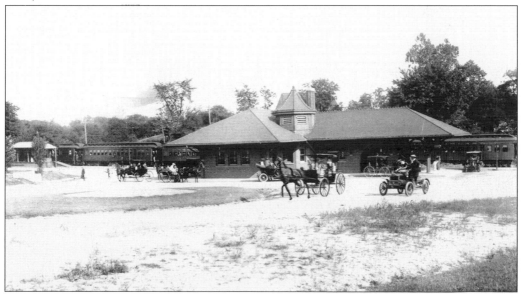

GLEN COVE STATION, C. 1898. Charles Pratt, Frank L. Babbott, and members of the North Country and Red Spring Colonies disliked the Glen Street railroad station because of the dusty freight yards and the station's proximity to local saloons. A hearing was held, and summer residents were permitted to maintain a depot at Titus Crossing. The station was built in a parklike setting. Audrey Hepburn is shown waiting in front of the station in the 1954 movie *Sabrina*.

THE FOLGER HOUSE. Henry Clay Folger, president of Standard Oil, and his wife, Emily, collected the world's largest collection of Shakespeare materials while living in their home by Nassau Country Club. They planned and funded the Folger Shakespeare Library in Washington, D.C., as a gift to the nation. After Henry's death in 1930, Emily completed the project. She lived in Glen Cove until her death in 1936. (Courtesy Robert L. Harrison.)

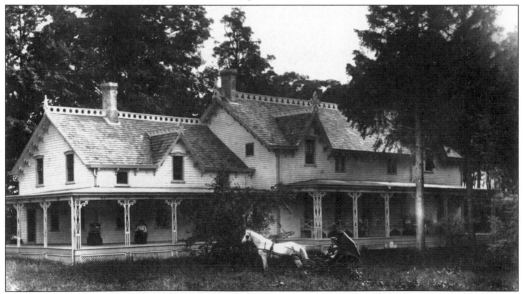

C. B. GRUMAN'S HOUSE, DUCK POND ROAD, C. 1896. This 1720 farmhouse, where Isaac Coles was born, belonged to Carmine B. Gruman, president of the Glen Cove Trust Company during the Gay Nineties. In the summer of 1896, an open-air performance of *As You Like It* was staged on the lawn for the benefit of St. Paul's Church under the direction of playwright Charles T. Vincent.

CHARLES T. VINCENT, 1858–1935. Born in Bristol, England, Vincent was a playwright, actor, and antiquarian. He first came to Glen Cove to stay at a theatrical boardinghouse in the Landing and eventually made Glen Cove his permanent home. He enriched the cultural life of the community with his interest in theater, film, and Americana. In later years he was proprietor of a book and antique shop on Cottage Row.

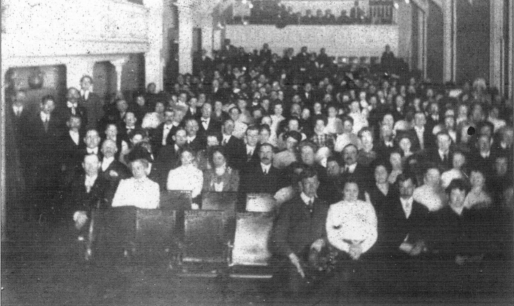

VINCENT OPERA HOUSE, 1909. Vincent started the first movie house in town. His thespian ventures made him the darling of the social and theatrical sets, and the *Brooklyn Daily Eagle* lists Lillian Russell as his houseguest at Harborside in 1899. After 1900, the opera house on Continental Place was a popular forum for Vincent's theatrical troop, as can be seen in this souvenir photograph by F. Seymour. (Courtesy Richard Smith.)

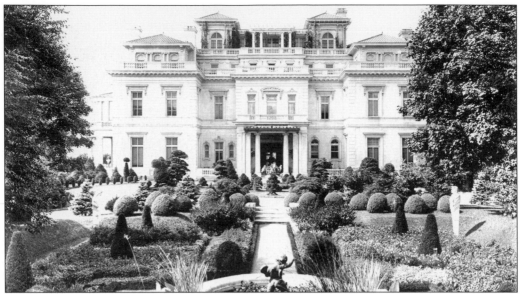

PEMBROKE, C. 1912. Pembroke was the palatial home of Capt. Joseph DeLamar, an investor who made his fortune in ship salvage and precious metals. The 80-room, C. P. H. Gilbert–designed mansion overlooked a private harbor and had its own water tower, stables, theater, gymnasium, and shooting range. After DeLamar's death in 1918, Pembroke passed to his only daughter, Alice. During Prohibition, the harbor was a favored port of rumrunners. Pembroke was the scene of lavish parties under the ownership of Marcus, then Arthur, Loew, owners of the Loews movie theater chain.

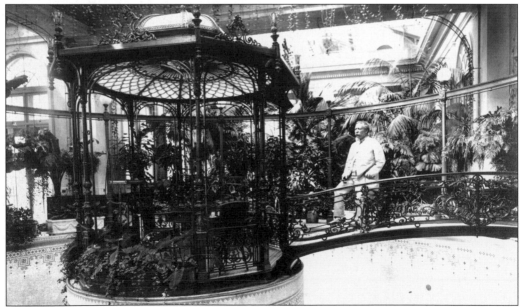

PEMBROKE'S WINTER GARDEN, C. 1912. DeLamar stands in the enormous glass palm house adjoining the mansion. It included a pool, grotto, Tiffany glass pendulum, and an aviary of exotic birds. The feel of paradise continued outside in the extensive Japanese and formal gardens. During the Loew era, the gardens were turned into a golf course. The house and conservatory were razed in 1968, and today the property is a gated community, Legend Yacht and Beach Club.

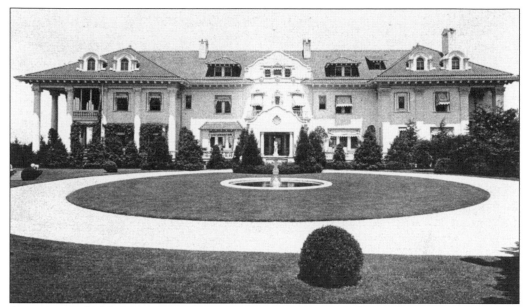

ALEXANDER C. HUMPHREY RESIDENCE, C. 1900. C. P. H. Gilbert, the favored architect of the Gold Coast "colonists," built this Mediterranean-style villa for Alexander C. Humphrey on Fresh Pond (Crescent Beach) Road. It was then sold to Emmett Queen, a Pittsburgh banker, and in turn to F. W. Woolworth, the five-and-dime magnate. In 1916, soon after Woolworth's purchase, it burned to the ground. The staff was able to carry much of the contents to safety.

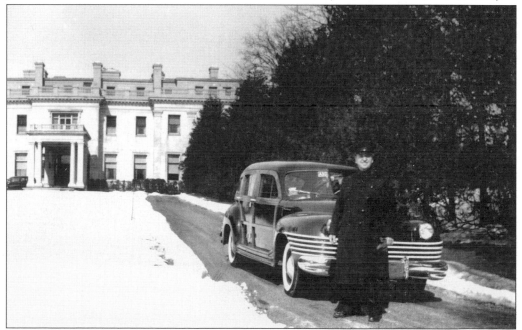

WINFIELD HALL, C. 1942. The drive, through a grand arched entrance, leads to a palatial white limestone mansion that Woolworth rebuilt on his 16-acre property. Patrick Dunne stands in front of Winfield Hall with the 1942 Chrysler wagon he drove for the next owner, Richard S. Reynolds, tobacco magnate and inventor of aluminum foil. The house, currently rented out for events and as a movie location, is for sale. (Courtesy Ben Dunne and Brenda Dunne Brett.)

THE ORIGINAL PRATT GATES, C. 1900. This photograph, taken by a Polish immigrant known only as Stanley, shows the entrance gates to 700 acres of Dosoris. The property was bought by Charles Pratt to create a great park in the English style to accommodate his country estate and residences for his children. Pratt hired Col. John Yapp Culyer to lay out 22 miles of bluestone roads, as well as a water supply and sewer system.

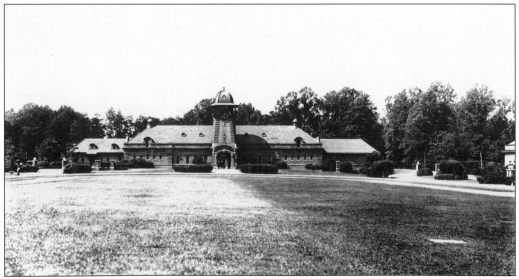

PRATT OVAL, C. 1898. Pratt Oval was the headquarters and nerve center for the seven Pratt estates. The stables, garages for motorcars, farm, and herd of Jersey cows were located here. The estates had 400 workers employed in their upkeep, and in 1935, the Pratt family paid 20 percent of the city's taxes. Today the Pratt Tower is a landmark and serves as a pool house in a private backyard.

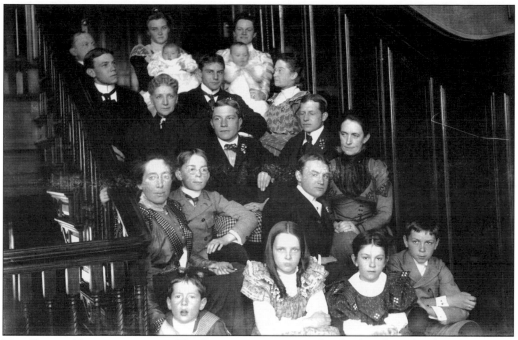

THE PRATT FAMILY, C. 1900. The Pratts were an exceedingly close-knit family. Their town houses on Clinton Hill were located in as near proximity as their country estates were. Scion Charles Pratt made his fortune in oil and gave his six sons and two daughters each $20,000 to build a country house. All but one daughter located them on the Dosoris Park property. (Courtesy North Shore Historical Museum.)

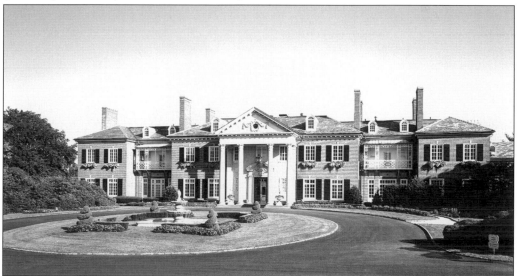

THE MANOR. The old John Coles residence was the center of Pratt family life while Dosoris Park was constructed. Charles Pratt died in 1891, but building continued under Mary Helen Richardson Pratt and sons. The farmhouse was rebuilt in Georgian Revival style and became the home of oil magnate and philanthropist John Teele Pratt and his wife, Ruth Baker Pratt, a two-term New York State congresswoman. The house, a set for many movies, is now the Glen Cove Mansion Hotel and Conference Center. (Courtesy Glen Cove Mansion.)

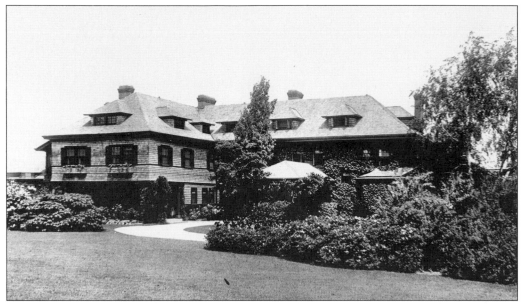

SEAMOOR, C. 1900. Charles Millard Pratt, the oldest Pratt son, married Mary Seymour Morris and resided at Seamoor. Their shingle-style home, constructed in 1890, was one of only two mansions Charles Pratt Sr. lived to see built. It was demolished in 1969 and is the only Pratt home that no longer stands.

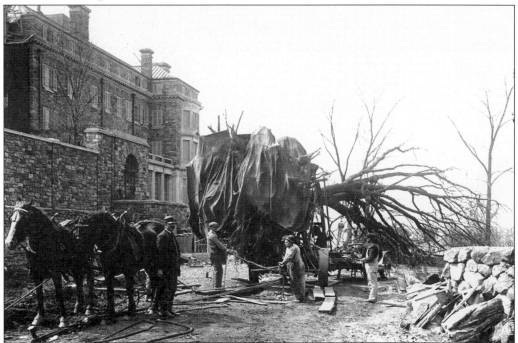

THE BRAES. Workers from Hicks Nursery prepare to plant a tree on the Braes, the estate of Herbert L. Pratt. The limestone-and-brick, Jacobean-style manor house, designed by James Brite, was built to replace the original shingle-style cottage. *Braes* is a Scottish term for land that slopes down toward the water. Since 1947, the estate has been the campus of Webb Institute of Naval Architecture and Marine Engineering. (Courtesy Hicks Nursery.)

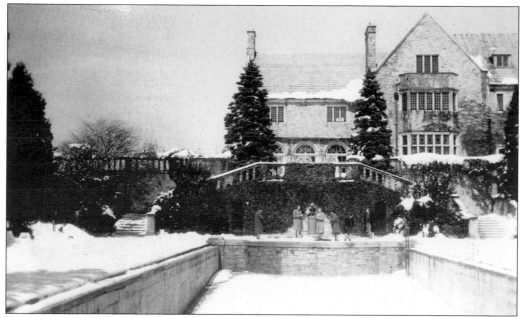

KILLENWORTH, C. 1944. The Jacobean manor house, constructed by the architectural firm of Trowbridge and Ackerman for George DuPont Pratt, had gardens of unsurpassed beauty. Since 1946, it has served as the country retreat of the Russian Mission to the United Nations. The southernmost part of the original property is now the YMCA. (Courtesy Ellie Puccianello.)

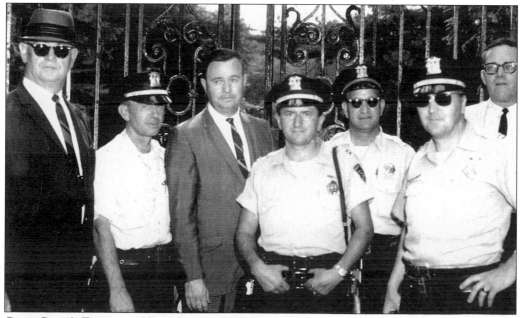

GLEN COVE'S FINEST AT KILLENWORTH'S GATES, 1960. From left to right, Frank McCue, chief of the Glen Cove Police; Joseph Cunninghan, chief of the Auxiliary-Special Police; Capt. Maurice O'Brien; Capt. Bill Katsikas; Capt. Mike Basile; Capt. Louis Rotunno; and Lt. Roger McCue guard the gates of the Soviet Mission during a special meeting between Nikita Khrushchev of Russia and other heads of state. During Mayor Alan Parente's administration, the Russians were suspected of spying and were banned from city beaches. (Courtesy Joseph Cunningham.)

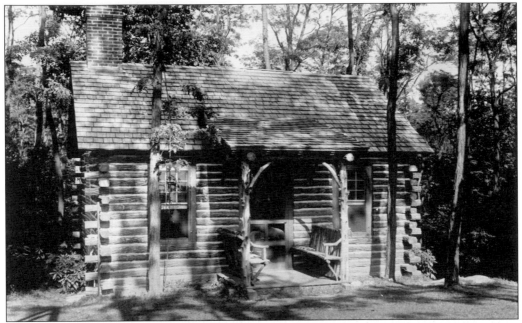

LOG CABIN AT WELWYN. The children of Harold I. and Harriet Barnes Pratt had this authentic log house to play in on the family estate, Welwyn. Since 1994, the property is home to the Holocaust Museum and Education Center. The Pratts were philanthropists who helped organize the Community Hospital at Glen Cove and donated land that the Glen Cove Library, post office, and old city hall were built on.

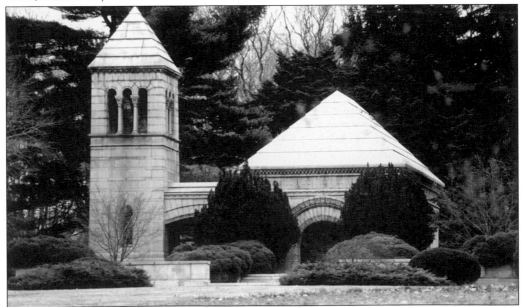

THE PRATT MAUSOLEUM. Surrounding the pink granite mausoleum on Old Tappan Road was 20 acres planted with rhododendrons, oaks, beeches, and evergreens. With bronze detailing and Tiffany windows, the Pratt crypt is a fitting tribute to Charles Pratt, who died suddenly after the purchase of Dosoris Park. The Pratt family still privately owns the cemetery. (Courtesy Michele Kutner.)

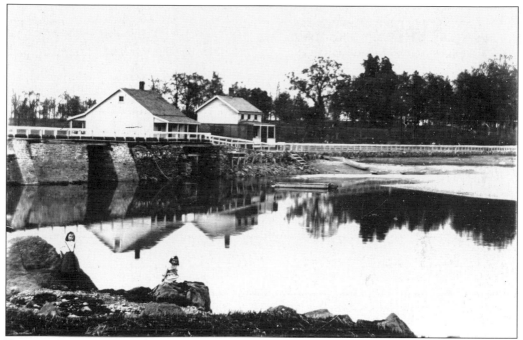

DOSORIS POND, 1911. The swampland of Dosoris, between the mainland and East and West Islands, was made into a true pond by damming the area. John F. Johnstone, supervisor of the Dana estate on West Island, photographed his daughters by the pond with the clam house, the residence of H. Coles, and the original mill sluiceway in the background.

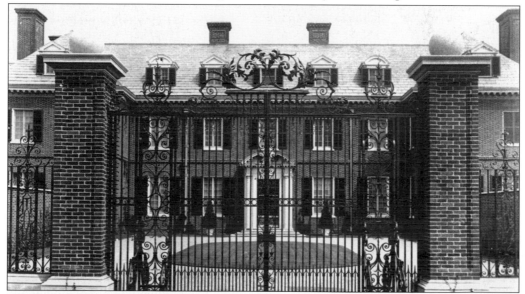

MATINICOCK POINT, C. 1930. Christopher Grant La Farge, the architect son of painter John La Farge, designed this Georgian Revival manor house for J. P. Morgan Jr.'s 250-acre East Island estate, Matinicock Point. The island retreat had prize-winning gardens, cow-dotted lawns, a 400-foot dock for yachts, and its own private guardhouse. After Morgan's death in 1943, the estate was rented to the Russian Mission and then became a convent. It was leveled in 1980. (Courtesy Nassau County Museum, Long Island Studies Institute, Hofstra University.)

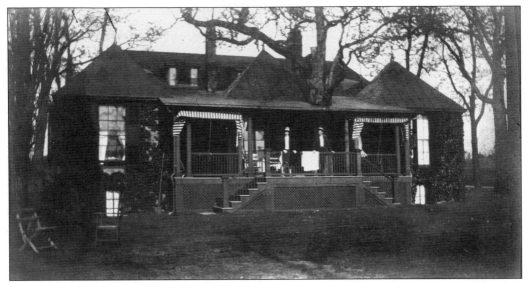

SHELL HOUSE, 1901. This private residence draws its name from its shell-encrusted ceiling. Built between 1850 and 1875, Shell House, a Tudor Revival–style cottage overlooking the Long Island Sound, is listed on the National Register of Historic Places. It was a boardinghouse for those employed on the Jacob, and later Morgan, estates. W. J. Paddison, who lived there as a Morgan chauffeur, took the photograph.

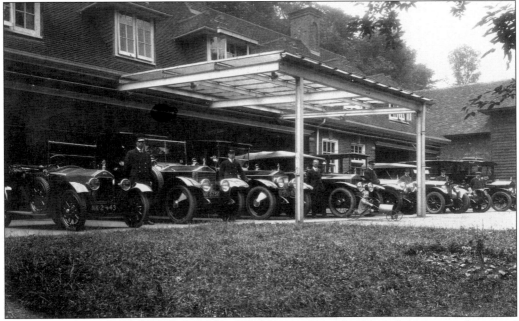

MATINICOCK POINT GARAGES, C. 1930. The Morgan fleet of cars was kept in top shape and high polish in a 16-car garage at Matinicock Point. Chauffeur Paddison was rewarded by the Morgans with his own automotive dealership for his heroic action during the assassination attempt on Morgan's life in 1915. (Courtesy Walter J. Paddison.)

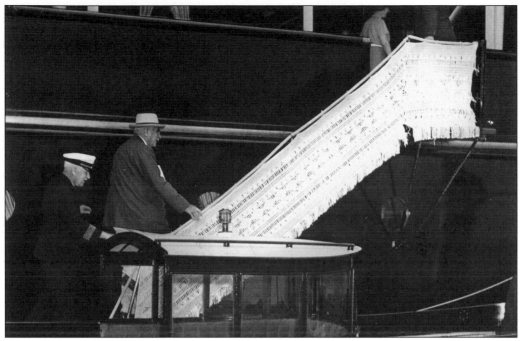

J. P. MORGAN BOARDS THE CORSAIR, C. 1930. In this rare photograph by "Drennan," Morgan transfers from his tender to his steam yacht, *Corsair*. Morgan was a private and reclusive man who did not like public displays or to be photographed. His daughters and granddaughters were kept strictly off the society pages. (Courtesy R. Allen Shotwell.)

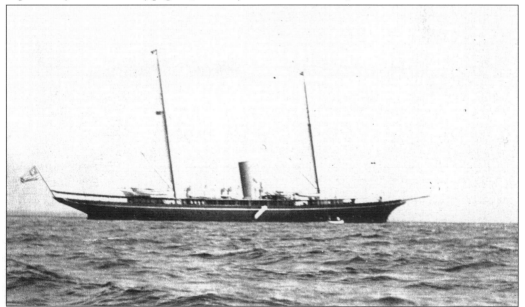

THE CORSAIR, C. 1930. Morgan commissioned the 343-foot *Corsair IV* from the ironworks in Bath, Maine. *Corsair*, which means pirate or privateer, was then the largest, most expensive private yacht ever built. It could be seen in the harbor or off Matinicock Point when Morgan was in residence. Charles Irvine, owner of the original Charlie's Store on Landing Road, was chief steward. (Courtesy Walter J. Paddison.)

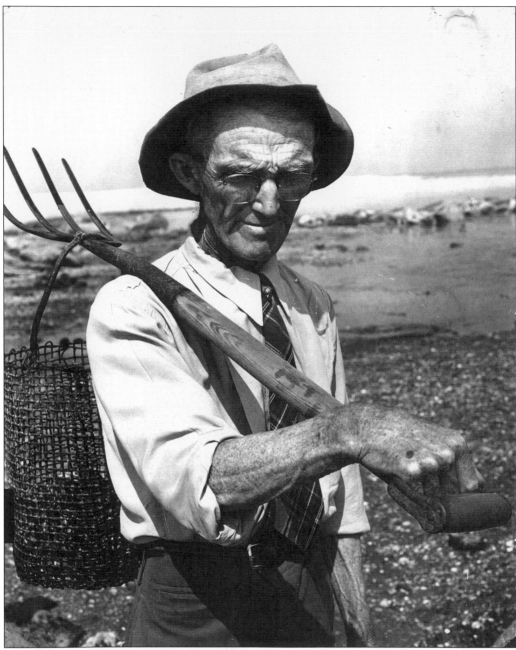

"DIAMOND" JIM MCLOUGHLIN, 1951. As a second-generation squatter on Dosoris Pond, Jim McLoughlin felt he had a right to his boat and bait business on Dosoris Creek and pond, despite the opposition of J. P. Morgan and his son, Junius. For three decades, he refused to be bought, hired, or moved by the Morgans, who held the official deed to the land. This local folk hero won his nickname for the diamond stickpin that he rescued from the mudflats and wore in his tie.

Five

THE VILLAGE

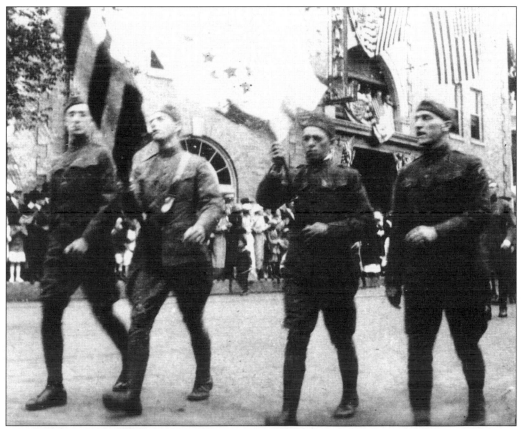

MEMORIAL DAY PARADE, 1920S. Fighting 69th World War I veterans, from left to right, Bill Spenncke, Jim Grogan, Len Dougherty, and Jim Cocks, march in the Memorial Day parade at the intersection of Glen and School Streets, then known as Oriental Corners. Bill Spenncke, a "Landing boy," was the model for the doughboy monument at the library. This intersection where the Oriental Hotel stood is the main crossroads at the heart of the village. (Courtesy Bob O'Rourke and VFW Post No. 347.)

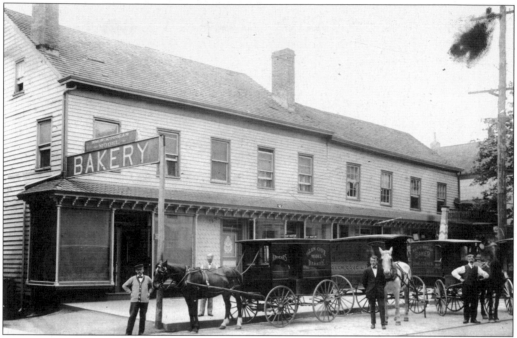

KINNEAR BAKERY, C. 1905. The Kinnear Bakery replaced the very successful Schwab's Bakery in the building once occupied by the Glen Cove Hotel. It was located on the south side of Glen Street opposite the present city hall. At one point in time, Glen Cove had 10 operating bakeries.

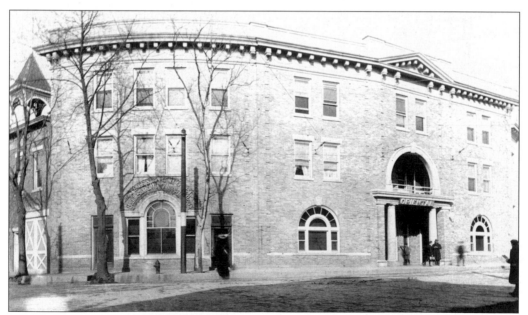

ORIENTAL HOTEL, C. 1910 Built on the property previously owned by Dr. G. Atmuller, the Oriental Hotel was reportedly named at the suggestion of a traveling salesman who convinced the proprietor that it sounded mysterious. The hotel existed in various forms from the 1890s until 1925, when the building was dismantled to one floor. The Oriental Stables, seen to the far left in the picture, predates the hotel. Today a martial arts studio occupies the corner.

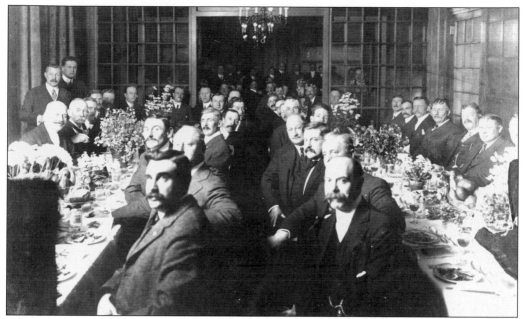

HORTICULTURAL SOCIETY BANQUET, C. 1904. Joseph Roll, proprietor of the Oriental Hotel, hosted the Annual Horticultural Society Dinner at the hotel. The back of the photograph notes that R. Frank Bowne, Mr. Partridge, Edward Underhill, and Jim Cocks were among the members of the all-male society in attendance. Note the newly electrified chandelier suspended from the ceiling.

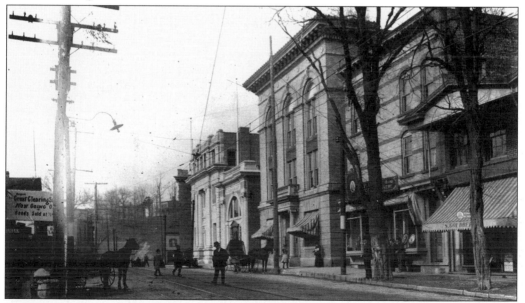

GLEN COVE MUTUAL INSURANCE COMPANY. The central building in the photograph is the Glen Cove Mutual Insurance Company, founded by William Weeks and other local businessmen after the insurance company failures following the great New York City fire of 1835. To the left of the office building are the Nassau Union Bank and Glen Cove Trust Company, which joined forces to become the Nassau Trust Company in 1953. In 1995, the bank buildings were physically joined and now function as Glen Cove City Hall, Court, and Civic Center.

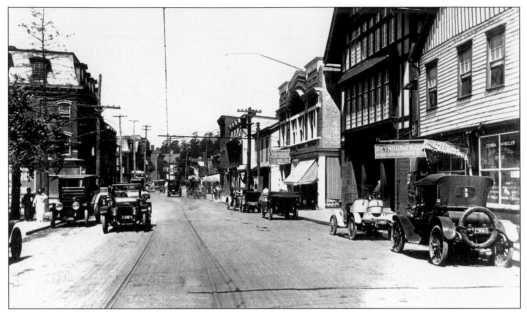

GLEN STREET, LOOKING WEST, C. 1905. In this view looking west down the trolley tracks on Glen Street, the following businesses on the north (right) side of the street can be identified as, from front to back, Corbin-Wheeler Real Estate Office, J. G. Seymour Tobacconist and Photographer's Studio, the old post office, and the Glen Theatre motion picture house.

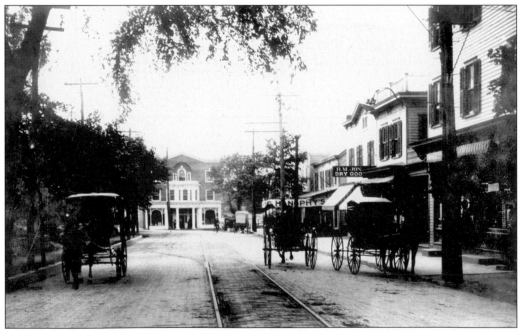

SCHOOL STREET, LOOKING SOUTH, C. 1910. Looking south down the trolley tracks on School Street, city hall can be seen in its original location on the south side of Glen Street. In 1918, it was moved several blocks down to the Village Justice Courts Building.

NASSAU UNION BANK, 1905. Formed in 1903, the Nassau Union Bank built this edifice in 1905 on the west side of the Glen Cove Mutual Insurance Company on property once belonging to Dr. James S. Cooley. In 1909, Glen Cove Trust Company was constructed next to it.

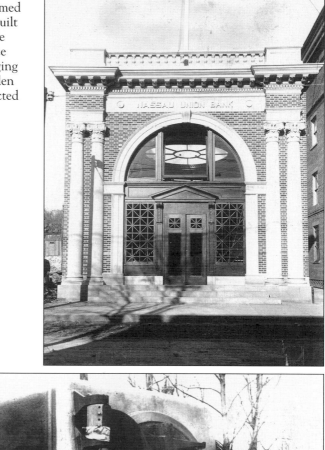

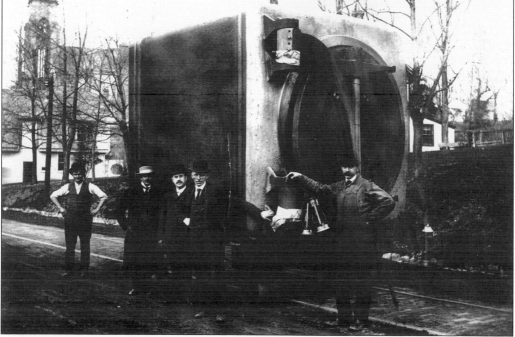

GLEN COVE TRUST COMPANY VAULT, C. 1909. Bank officers first cashier David N. Gay, president Carmi B. Grumman, Charles P. Valentine, and two unidentified men stand before the Glen Cove Trust Company vault as it is transported along the trolley tracks to the bank location on Glen Street. St. Patrick's Church can be seen in the background.

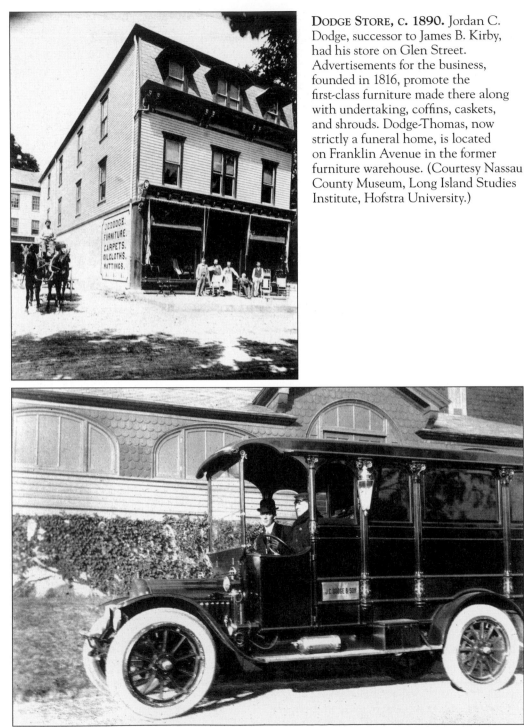

DODGE STORE, C. 1890. Jordan C. Dodge, successor to James B. Kirby, had his store on Glen Street. Advertisements for the business, founded in 1816, promote the first-class furniture made there along with undertaking, coffins, caskets, and shrouds. Dodge-Thomas, now strictly a funeral home, is located on Franklin Avenue in the former furniture warehouse. (Courtesy Nassau County Museum, Long Island Studies Institute, Hofstra University.)

DODGE HEARSE. This Dodge hearse replaced the original home conversion Model T car, which replaced a horse-drawn wagon. Dodge-Thomas, now operated by the Minutoli family, is the oldest funeral home and one of the oldest continuously operating businesses in New York State. (Courtesy Guy and Jeanine Minutoli.)

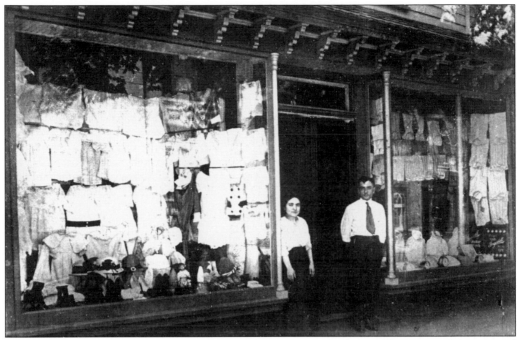

SINGER'S DEPARTMENT STORE, C. 1913. Rebecca Singer Zatlin and Benjamin Singer stand outside the family store on School Street. The business was begun in the 1890s as a peddling operation by their Lithuanian-born father, Barney, who went door to door selling needles, thread, and notions. The general store opened in 1901 and developed into a full department store, where everyone from Jane Norton Morgan to the newest immigrant housemaid shopped. (Courtesy Burt Singer.)

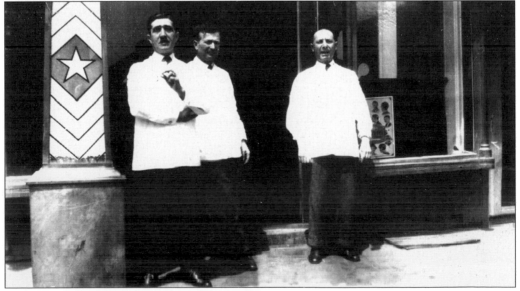

TANCREDI'S BARBERSHOP, 1920S. Thomas Tancredi, on the left, stands with two unidentified members of his staff outside his barbershop on Pulaski Street. The shop tended to the tonsorial needs of the city for many years, and there are still a few old-timers around who remember Tancredi's haircuts. (Courtesy Dennis Dowling.)

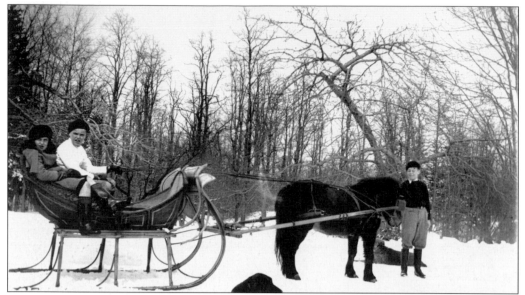

HORSE-DRAWN SLEIGH. In the early years of the city, racing sleighs through the snowy streets was a favorite winter pastime. The contestants would assemble at Schleicher's Hotel in the village and race down to the railroad station at the other end of Glen Street. The Hester family's sleigh was drawn by Frisky. (Courtesy Ben Dunne and Brenda Dunne Brett.)

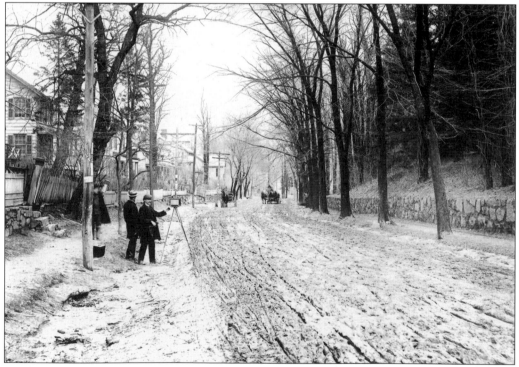

COTTAGE ROW, C. 1902. A photographer with his view camera can be seen photographing a horse-drawn wagon coming down snowy Cottage Row. One of the oldest streets in the city, Cottage Row was home to many small businesses and to boardinghouses for the men who worked in the factories.

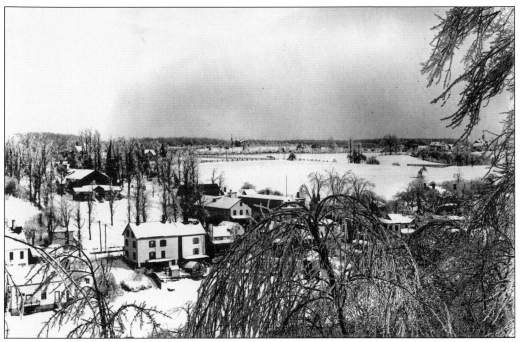

VIEW FROM E. T. PAYNE'S, C. 1902. This picture was taken from the home of Edward T. Payne, a wealthy and well-respected lawyer who lived in a Queen Anne–style cottage atop Robinson's hill. The view looks out over the valley from Hendrick Avenue toward St. Paul's Church, which faced Glen Street at that time.

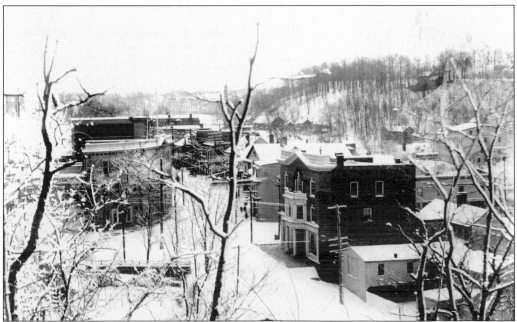

MILL HILL, SNOW VIEW, C. 1902. This photograph, taken from the summit of Mill Hill, looks east down Glen Street and out over the village. The Oriental Hotel is on the left, and the old city hall is on the right. It was probably taken during the winter of 1902, when the city was besieged by a week of snow and ice storms.

GLEN STREET STATION, 1878. The original wooden railroad station and Stroppel's Inn can be seen in this early view of the Glen Street station. In 1868, the rail line was extended from Glen Head to Glen Cove. The depot officially opened for business on May 16 of that year, when the steam engine *General Sherman*, pulling the 10:15 a.m. train from Jamaica, arrived at the station.

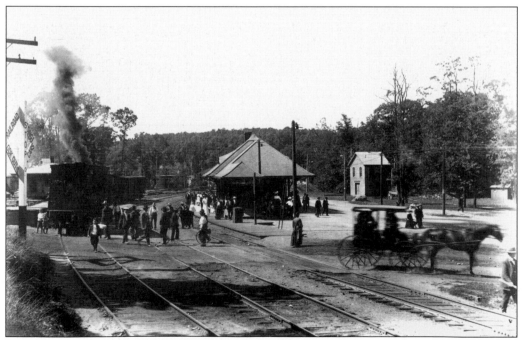

GLEN STREET STATION, 1907. The original wooden station house was replaced by this brick building sometime after 1878. Corn and starch products were transported by rail at this depot. Photographer Fred Stark captured the feel of the busy station and freight yard.

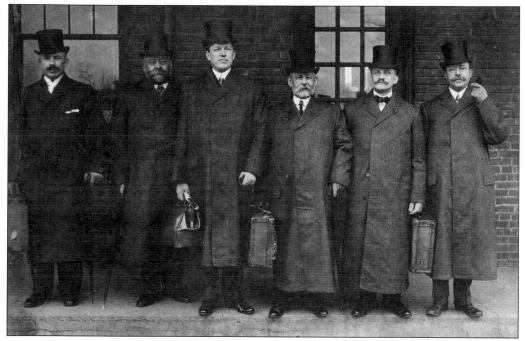

ON TO TAFT'S INAUGURATION, 1909. Leading citizens of the city, Ellwood Valentine, fourth from left; William Luyster standing to his right; and Franklin A. Coles, extreme right, assembled with three (unidentified) gentlemen at the Glen Street station for the trip to the inauguration of William Howard Taft in Washington, D.C. Taft was sworn in as the 27th president of the United States on a snowy March 4, 1909.

TRUCK BEFORE THE TROLLEY, C. 1900. Before the implementation of the trolley line, passengers were transported about in a primitive open-sided conveyance. The trolley line started service around 1902 and had its last official run on November 15, 1924.

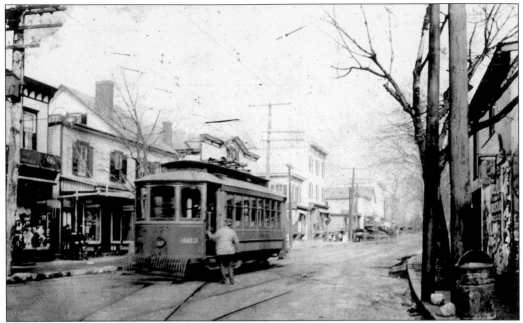

GLEN COVE RAIL ROAD COMPANY, C. 1905. The Glen Cove trolley ran parallel to the railroad tracks from the Sea Cliff station to the Glen Street station. Then it followed Glen Street to School Street in the village, turned on Cottage Row to Hill Street, and headed west on the Place to Ellwood Street. Finally it turned on Clement Street to Carpenter Street, angled north on John Street, and headed west down Landing Road to the steamboat dock.

TROLLEY AT SEA CLIFF STATION, C. 1908. The Sea Cliff station house, built in 1888 and listed in the National Register of Historic Places, is actually within the city limits of Glen Cove. This Henry Otto Korten view shows the station in its glory days with passengers in straw hats making their way to the trolley. Korten had a business photographing Sea Cliff and sold his pictures in postcard form to tourists visiting this popular Victorian resort. (Courtesy Sea Cliff Village Museum.)

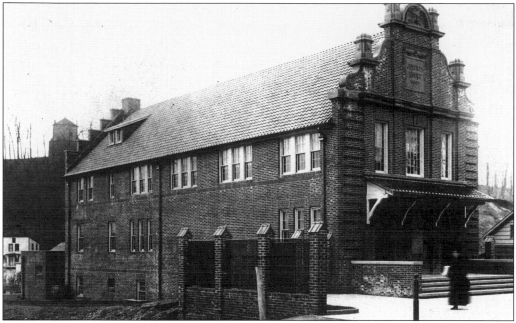

VILLAGE JUSTICE COURTS, 1910. The Village Justice Courts Building was constructed in 1907 for the town of Oyster Bay. In 1918, it became headquarters for the newly formed City of Glen Cove and replaced the old unsanitary village hall. When city hall moved to Bridge Street, the building served as a courthouse and police headquarters. Now in its 100th year, the structure is being renovated as a home for the North Shore Historical Museum.

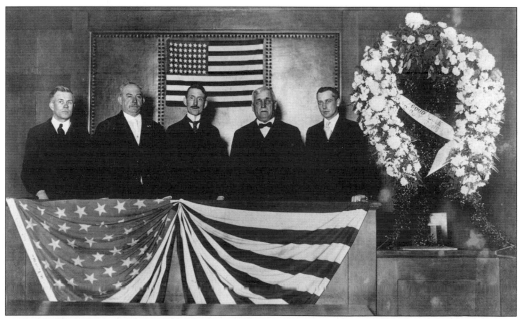

THE FIRST MAYOR AND CITY COUNCIL, 1918. On New Year's Day 1918, Mayor James E. Burns, a practicing physician, was sworn in as the first mayor of the newly established City of Glen Cove. He is pictured (center) with the first city council. Burns served the community for six terms and shaped the modernization of the infrastructure and public health services of the city.

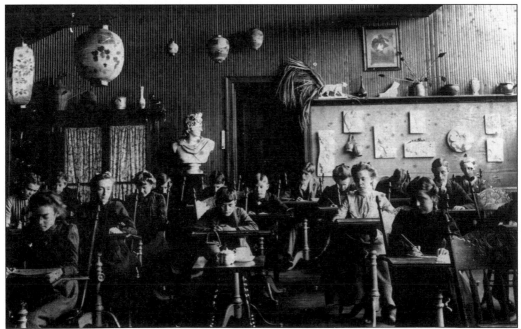

Dear Mr. Roger

I was able to get

Il Trovatore.

Yours respectfully

Lou

ansen

Glen Cove,
April 12, 1905

1630 High School, Glen Cove, L. I. PUBL. BY I.I. POST CARD CO., NEW YORK.

GLEN COVE HIGH SCHOOL, C. 1905. The Glen Cove High School building on Forest Avenue was dedicated in 1893 during the celebration of the city's 225th anniversary. Built with funds and land donated by the Pratt family, the high school was the most impressive on Long Island. The building was torn down and a new high school built on the site in the 1930s. In 1962, a modern school was built a mile north on Dosoris Lane.

DRAWING CLASS, 1905. Students were rigorously trained in the arts and crafts during the early years of the 20th century. In addition to traditional schooling, Glen Cove High School offered classes in visual arts, carpentry, joinery, Venetian ironwork, clay molding, and all types of needlework. Many students left school at 16 to work in the trades and support their families.

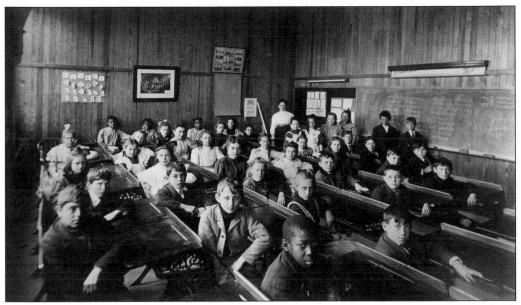

GLEN COVE PRIMARY SCHOOL, C. 1900. Classes in the old Glen Cove Central Primary School, on the corner of Dosoris Lane and Forest Avenue, were as racially and ethnically diverse as classes are today. School district No. 5 was established in 1857 by an act of the state legislature. The previous school building, on the corner of Highland Road and School Street, became the Neighborhood House and burned down around World War I. (Courtesy Claire Donohue.)

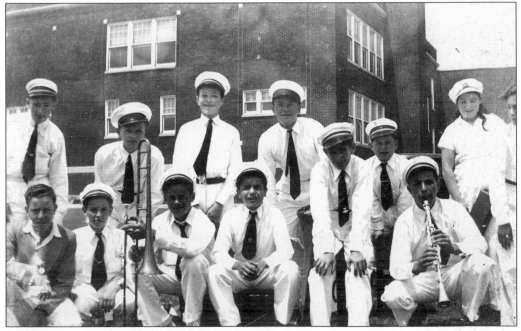

JUNIOR HIGH SCHOOL BAND, C. 1941. Middle school was known as junior high school when this picture was taken. Bandleader Robert Belissimo, bottom right, prepares to play his instrument while Walter Paddison, top row third from the left with his classmates, smiles for the camera. Glen Cove schools have always been known for the high quality of their music programs and the excellence of their bands. (Courtesy Walter J. Paddison.)

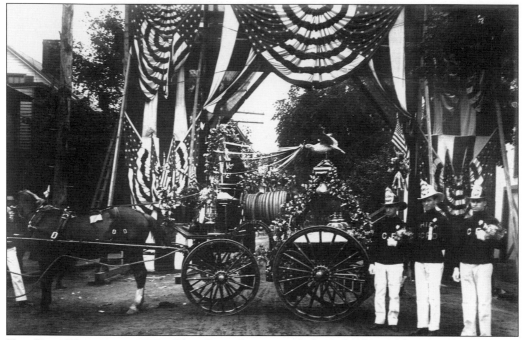

THE FIRE WAGON, C. 1902. Glen Cove firemen and their chief stand beside a horse-drawn fire wagon decorated in high Victorian style. The Glen Cove Volunteer Fire Department was founded in 1838 by a group of concerned citizens who met at the home of William Weeks. Note that by 1902 electrification had come to Glen Cove, but the street is still unpaved.

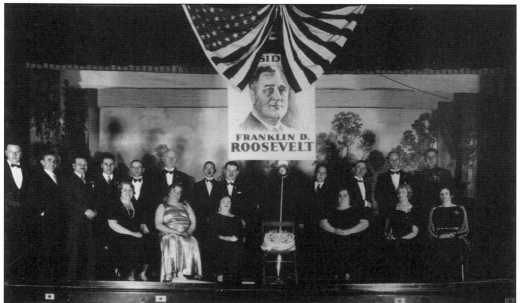

THE ELK'S CLUB, 1934. E. J. Seymour, town photographer, took this picture of the FDR Birthday Anniversary Committee, which organized a ball at the Elk's Club to raise money for the Warm Springs Foundation's fund to stop the spread of infantile paralysis. The occasion, which celebrated the birthday of Pres. Franklin Delano Roosevelt, featured dancing, a speech by Mayor Harold Mason, an honorary birthday cake, and a live radio broadcast from the president.

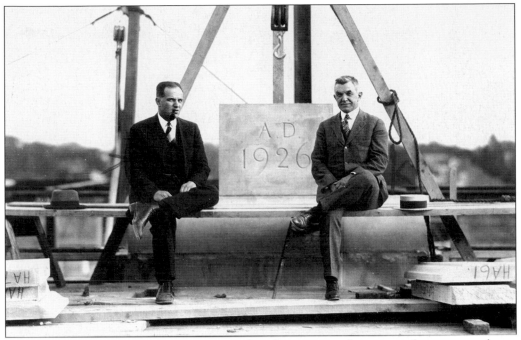

THE HOSPITAL CORNERSTONE, 1926. Trubee Davison, newly appointed secretary of war, and Honorable Mayor William H. Seaman sit for a photograph by Lenox Decker at the laying of the cornerstone of the North Country Community Hospital of Glen Cove. (Courtesy Richard Smith.)

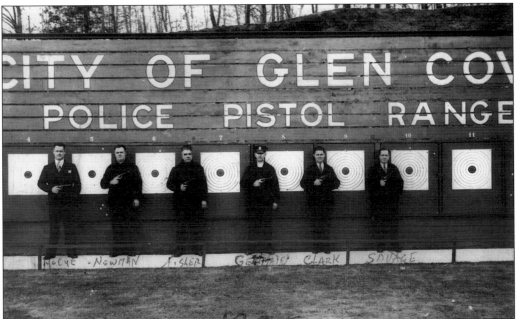

POLICE PISTOL RANGE, C. 1935. The original City of Glen Cove Pistol Range was located off Sea Cliff Avenue. Standing before the target area are, from left to right, officers Frank McCue, Mike Newman, Chester Fisher, Jim Germain, James Clark, and Clement Savage. (Courtesy Ralph Suozzi.)

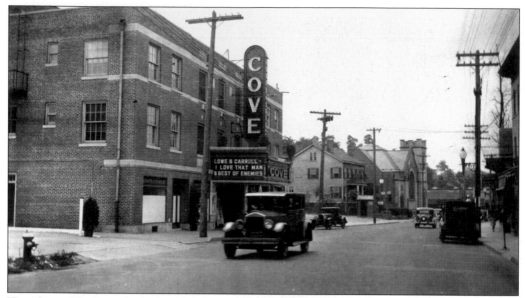

THE COVE THEATRE, C. 1933. The Cove Theatre on School Street opened in 1927 featuring silent movies and vaudeville acts that included performing seals. Part of the Calderone Chain, it was one of the largest movie houses on Long Island. Beyond the theater, Mayor James E. Burns's home can be seen. Today the Regency Assisted Living Facility has replaced the theater, and the house, the last standing on School Street, contains a sign shop and Latino markets.

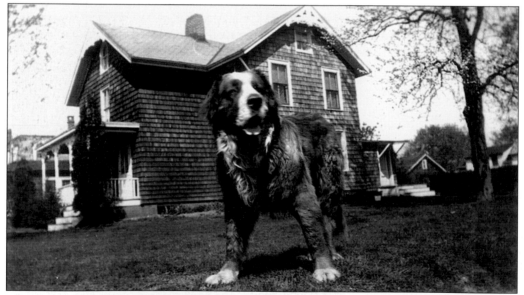

BUTCH, C. 1946. During the 1940s, Butch, a Saint Bernard who belonged to the Miller family of Forest Avenue, was the biggest celebrity in Glen Cove. He was a regular in the local meat markets and in front of the potbellied stove in the Glen Street station. His naps in the middle of village streets and forays by train to the butcher shops of Oyster Bay won him notoriety and fame. He was featured in *Life* magazine, had his own comic book, and starred in a movie that premiered at the Cove Theatre. (Courtesy Michele Kutner.)

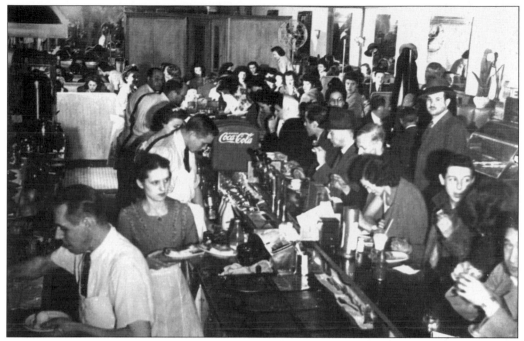

HENRY'S, APRIL 6, 1945. Henry's Luncheonette has been a fixture on Glen Street since 1929. Here the busy dining room is shown near the end of World War II. Its Sunday brunch, as well as the handmade chocolates and homemade ice cream, have been town favorites for nearly 80 years. (Courtesy Henry's Luncheonette.)

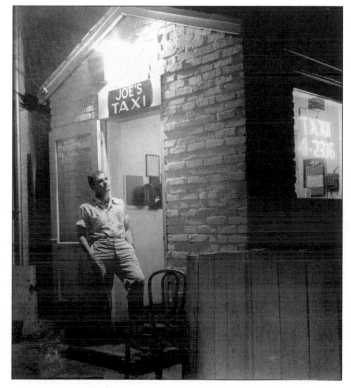

TAXI JOE'S, 1945. Joseph Palmirotto Jr. leans against his taxi booth waiting for a fare. His father, Joseph Palmirotto Sr., started the business in 1919 with one Model A Ford car. By 1928, he had three limousines and was the driver of choice for the Gold Coast estates. On Sundays, the Palmirottos made the "church run" for the butlers and the maids. (Courtesy Joseph Palmirotto.)

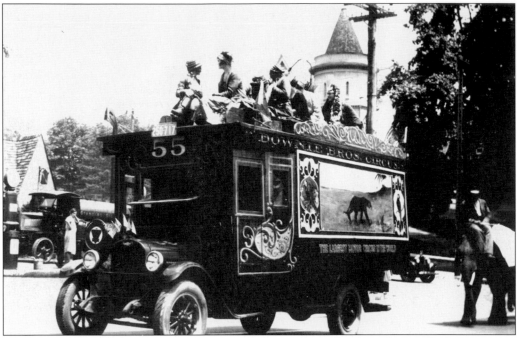

DOWNIE BROTHERS CIRCUS, 1920S. A wagon from Downie Brothers Circus, the largest motor circus in the world, passes the Presbyterian church on School Street as it turns onto Cottage Row. From there, the circus parade continued up Landing Road to the Elk's Club property on the former Beach Estate. The circus acts featured several elephants and a group of cowboys on miniature horses. (Courtesy Ben Dunne and Brenda Dunne Brett.)

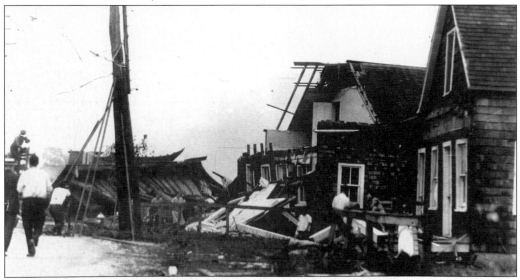

THE WATERSPOUT, 1926. In August 1926, a twister formed in the harbor and came up onto Front Street (Shore Road), tearing roofs and porches off houses. The most serious damage was to the home of motion picture actor Lynn Hammond, whose house renovations had been completed just hours before. Debris including seaweed and bits of lace curtain was found as far away as the links of Nassau Country Club. On August 12, 2005, 79 years later, an F1 tornado did similar damage along Dosoris Lane.

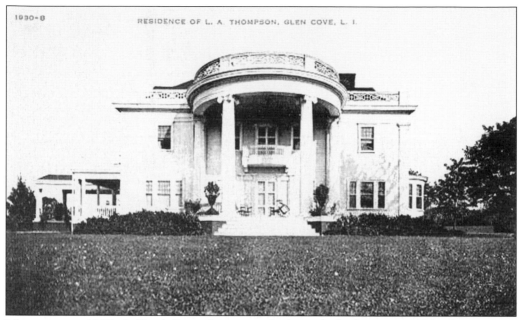

MARCADA, C. 1905. A Greek Revival mansion, built on the highest point of the former Craft Farm, was the home of La Marcus Adna Thompson, inventor of the Switch Back Sensation Railway. His gravity-based ride, precursor to the modern roller coaster, stood on the spot in Coney Island occupied by the Cyclone. The estate house, which overlooked the harbor, was equipped with an astronomical observatory. (Courtesy Sea Cliff Village Museum.)

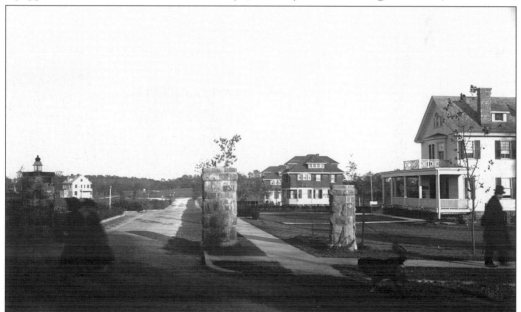

THOMPSON PARK, 1909. These stone pillars still mark the western entrance to Thompson Park. The once-elegant housing development was the brainchild of La Marcus Adna Thompson, who intended to create a "congenial community for 50 families looking for the best at moderate price." The 14 acres of chestnut woods, which stretched to the Sea Cliff train station beyond the park, were later developed into Trousdell Village. (Courtesy Sea Cliff Village Museum.)

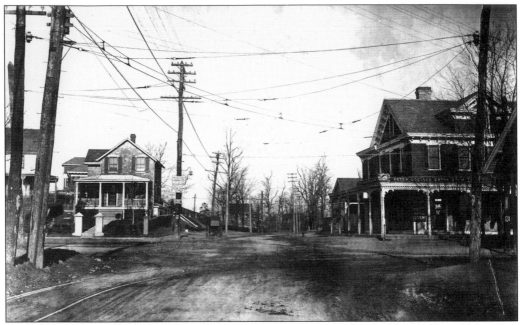

CROSSROADS OF SEA CLIFF AND GLEN COVE, C. 1910. Looking north down Back Road Hill toward Glen Cove, the Colony Hotel can be seen on the eastern corner of Glen Cove Avenue and Sea Cliff Avenue. The hotel was replaced by the Colony Arms, now the Jin Jin Hotel. The house on the west side of the street appears in 2008 much as it did nearly a century earlier. (Courtesy Nassau County Museum, Long Island Studies Institute, Hofstra University.)

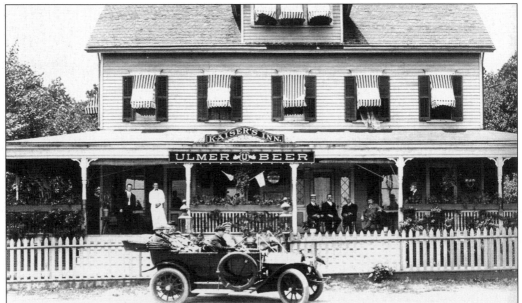

KAISER INN, C. 1900. The lively Kaiser Inn, captured here in its glory by photographer Henry Otto Korten, was the first hostelry visitors saw after debarking at the Sea Cliff station. The Kaiser Inn, popular with German Methodists coming for camp meetings at the tabernacle in Sea Cliff, was located just outside the drive to Thompson Park. This area is within the boundaries of present-day Glen Cove.

Six

FAITH AND DIVERSITY

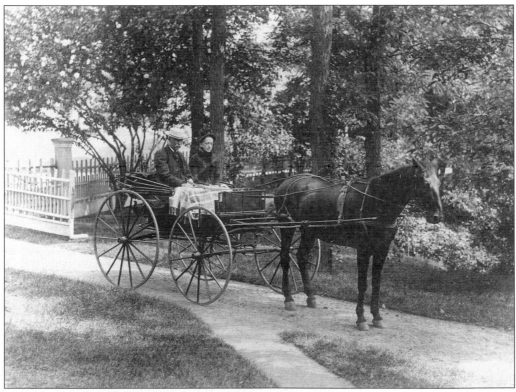

RETURN FROM MEETING, 1887. Isaac and Mary Willits Coles return from a First Day meeting in their horse and buggy. Although many of the settler families became Quakers, from its earliest days, Glen Cove has been a city of many faiths and vast ethnic diversity. Its Methodist, Episcopal, Catholic, and Jewish congregations are among the oldest on Long Island. Present-day Glen Cove supports more than 20 different houses of worship, including a Sikh temple.

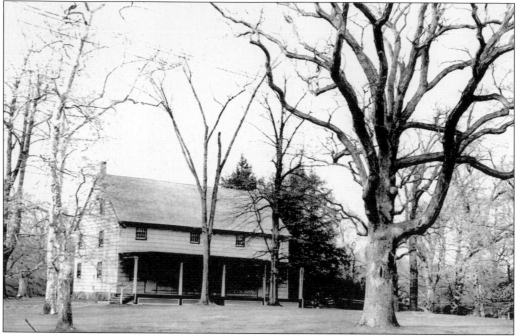

FRIENDS MEETINGHOUSE. Matinecock Friends Meeting House is the oldest continuously active Quaker meeting in the United States. After a devastating 1985 fire, the meetinghouse was rebuilt as closely as possible to John Mott's 1725 design. Listed on the National Register of Historic Places, it is located on the northwest corner of Duck Pond and Piping Rock Roads.

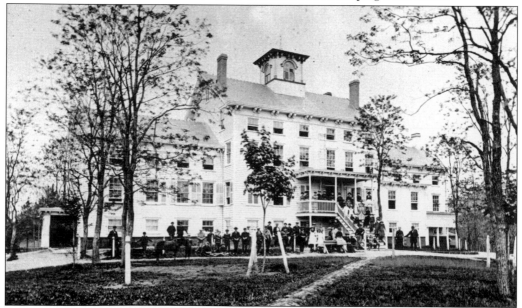

FRIENDS ACADEMY, 1880s. Friends College was founded in 1875 by prominent Quaker Gideon Frost, "for the purpose of giving to the children of Friends and others the opportunity to gain a thorough education in connection with a guarded moral training." Students attended Friends College in the wooden building from 1876 until 1894, when the brick building was built, and the name changed to Friends Academy. (Courtesy Friends Academy.)

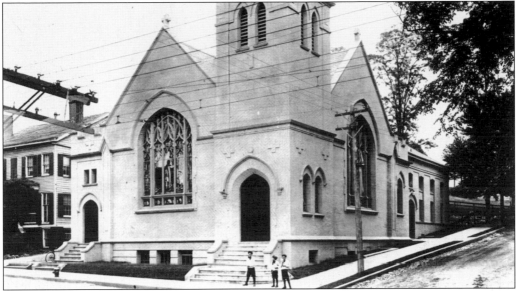

CARPENTER MEMORIAL METHODIST CHURCH, 1909. Methodism began in the 1780s in Glen Cove with the arrival of Rev. Ezekiel Cooper, an itinerant preacher and circuit rider. In 1806, the first Methodist camp meeting was held in Landing Grove with attendees coming from upwards of 100 miles away. Sunday services were held in the homes of Jesse Coles and Latting Carpenter until 1827, when they were moved to the schoolhouse. In 1844, land was secured on School Street and the first Methodist house of worship was built. The building pictured replaced the original white frame church.

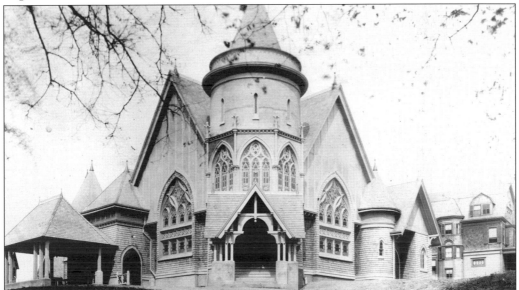

THE PRESBYTERIAN CHURCH, C. 1905. Many of the first Presbyterians worked in the starch works. Services were held south of the ponds in Continental Hall, owned by Wright Duryea, president of the factory. In 1876, an exquisite, small church was built on Hendrick Avenue. It had sofa pews of black walnut and stained-glass windows. When the congregation outgrew it in 1905, land was secured on the corner of North Lane and School Street, and the present church was built.

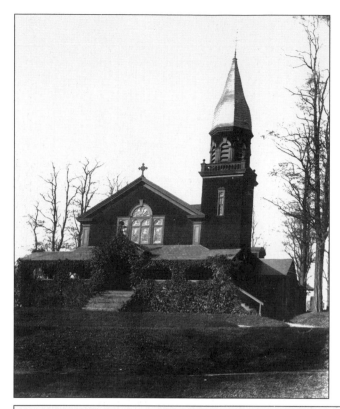

St. Paul's Episcopal Church, c. 1890. The first Episcopal service in Glen Cove was held in 1823, and 10 years later an independent parish formed. In 1834, a clapboard church was built high on the hill above Glen Street. That church was replaced in 1885 by this Romanesque-style building. In 1938, when this building was declared unsafe, land was secured from Dr. William H. Zabriskie and the church was razed and rebuilt facing Highland Road. Members of many prominent city families are buried in the churchyard.

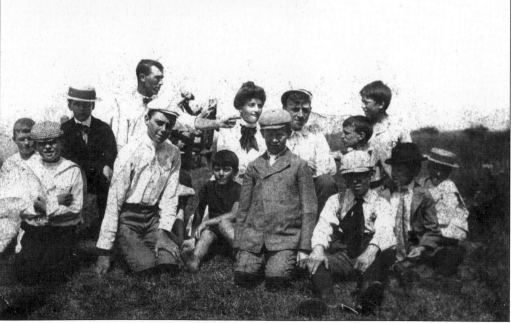

St. Paul's Choir Outing, 1898. Under the auspices of Rector J. W. Gammack, the St. Paul's Church choir and the church organists met at East (Pryibils) Beach for a picnic and outing. The Morgan family was counted among the parishioners of St. Paul's Church until the founding of St. Johns of Lattingtown.

CALVARY AME CHURCH ON DOSORIS LANE, C. 1900. When freedom seekers came north, they established themselves with the help of the Quakers and founded the African Methodist Church of Cedar Swamp. In 1862, the church moved to Dosoris Lane in Glen Cove. The church incorporated with the African Methodist Episcopal Church and in 1913 moved to its present location on Cottage Row. During the 1950s, church member Alberta Hersey researched the history of this African American community and established the Hand of Love Project, which provided food and clothing to the needy. Today the Dr. Alberta Hersey Foundation continues her work. (Courtesy Jean Hersey.)

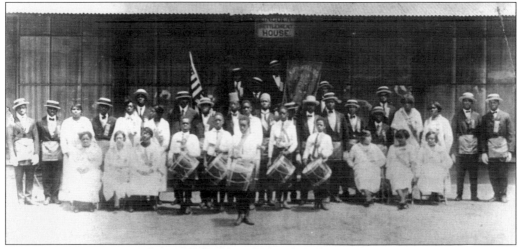

LINCOLN SETTLEMENT HOUSE BAND, C. 1925. Founded in 1920 under the auspices of Mrs. George D. Pratt, Lincoln House was a social organization for the African American residents of Glen Cove and the surrounding area. The first director was Ethel Lawrence, daughter of Rev. Theodore Lawrence, pastor of the Calvary African Methodist Episcopal Church. In the 1970s, the settlement house became the Glen Cove Boys and Girls Club.

ISAAC BESSEL, C. 1897. In the 1880s, Isaac Bessel, a horse farmer and feed dealer, came to Glen Cove with his wife, Esther, and settled on Back Road Hill. Bessel owned a Torah, and his house became a stopping place for Jewish travelers unable to reach home before Sabbath. As the community grew, services were held in the opera house on Continental Place. In 1906, Isaac was elected first president of the Congregation Tiffereth Israel. The Bessel Torah is still read from during Saturday services. (Courtesy Froma Bessel.)

THE FIRST BAPTIST CHURCH. The First Baptist Church was incorporated in 1919. Meetings were held in the Ritter Building, then in a church on the south side of Cottage Row. When Congregation Tiffereth Israel vacated its temple on the site of the old opera house on Continental Place, the building became the First Baptist Church. Civil rights leader James Davis was a member of this church.

THE BEACH ESTATE ENTRANCE, C. 1900. Stone pillars that flanked the entrance to Judge Elias Beach's 14-acre, 19th-century estate on Hill Street today mark the entrance to Congregation Tiffereth Israel's temple. The congregation bought the property from the Elk's Club and built the temple in 1961. Congregation Tiffereth Israel is the oldest continuously practicing Jewish congregation on Long Island.

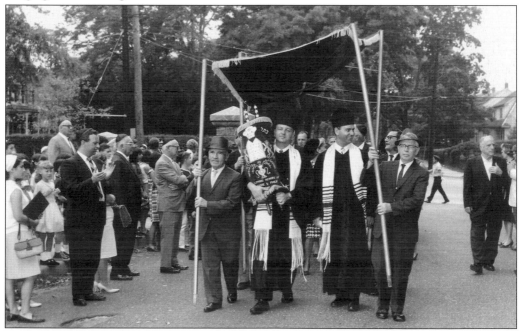

DEDICATION OF THE ZENDEL TORAH, C. 1965. The procession accepting the Zendel Torah, on the grounds of Tiffereth Israel on Hill Street, was lead by, from left to right, Arthur Buxenbaum Gabbai and keeper of the minyan Rabbi David L. Blumen, cantor Maurice Casuto, and Aaron Fishman. (Courtesy Froma Bessel.)

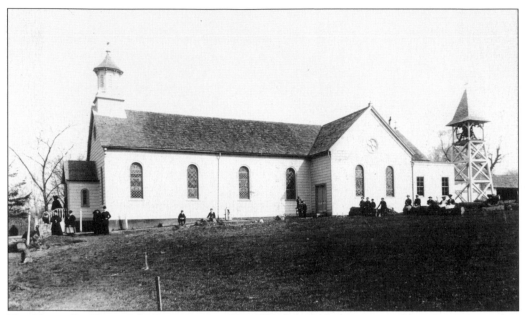

THE FIRST ST. PATRICK'S CHURCH, C. 1890. The first Catholic mass in Glen Cove was said in Garvies Point on an altar fashioned from a flat rock. Then, in 1857, a tiny wood frame church was built at the corner of Pearsall Avenue, on the hilltop where St. Patrick's Church stands today. St. Patrick's Church is the oldest parish in the diocese and the only parish continuously staffed with a resident pastor and associates since 1856.

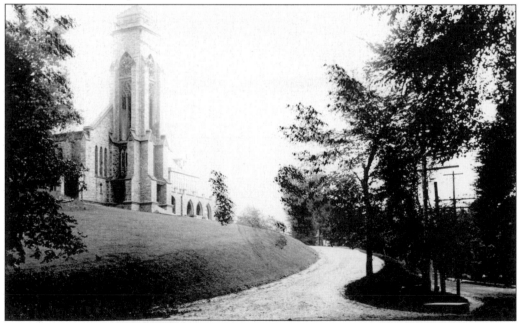

ST. PATRICK'S CHURCH, 1899. Built of fireproof gray granite with rock facing and terra-cotta tracery, this Irish Gothic masterpiece of monastery-style architecture replaced the little frame church. The earliest Catholics were Irish immigrants who came to work in the starch factory and on the estates. Later Catholics came from Germany, Poland, Italy, and more recently from Spanish-speaking countries. All of Nassau County was once part of St. Patrick's parish.

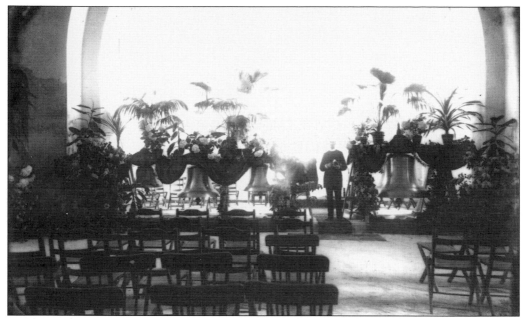

DEDICATION OF THE BELLS, 1899. The first set of bells in St. Patrick's Church's tower weighed in at 2,295 pounds. The Meneley Bell Company cast these bells and those of all the churches in Glen Cove. In this photograph, preparations are being made for the blessing of the bells before their installation. In 1984, the clock tower steeple was completely renovated and a new larger set of bells installed.

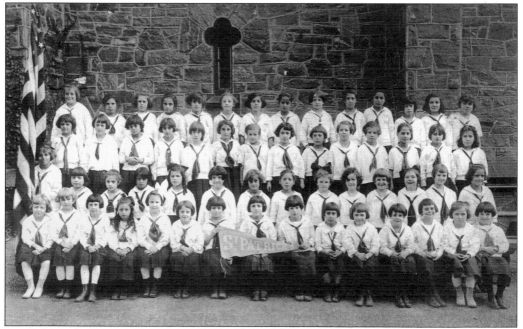

ST. PATRICK'S SCHOOL CLASS, C. 1916. St. Patrick's Parochial School opened on September 13, 1915. The gray granite school had 18 classrooms, 2 recreation halls, 5 offices, a book room, and an auditorium. The teaching staff, School Sisters of Notre Dame, lived in a convent on the grounds that had its own chapel, interior courtyard, and cloister.

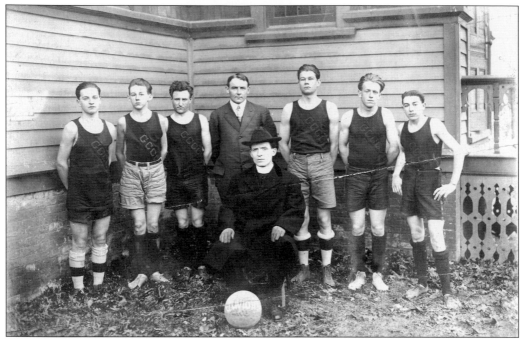

GLEN COVE CATHOLIC CLUB, 1905. Basketball is a sport at which the Catholic community has long excelled. Manager John Donohue, center in the coachman's uniform, and his team pose proudly with parish priest Fr. Bernard O'Reilly. (Courtesy Claire Donohue.)

THE RAZING OF ST. HYACINTH'S, 2005. Polish immigrants who came to Glen Cove built a wood frame church on the corner of Cedar Swamp Road and Hazel Street in 1909. Later it was faced in brick. When the new St. Hyacinth's was built in Glen Head, this building was taken over by the Greek Orthodox Church of the Resurrection. In 2005, a new Orthodox Church was built in Brookville, and the old church building was demolished.

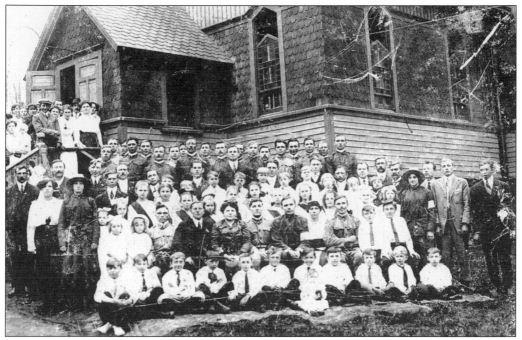

THE POLISH NATIONAL HOME, 1922. The Polish Hall, as it is known, was founded in the 1920s to provide Polish residents of Glen Cove and surrounding communities a place for the study and celebration of Polish culture, history, and literature. It also provided classes in Polish and English language. (Courtesy Polish National Home.)

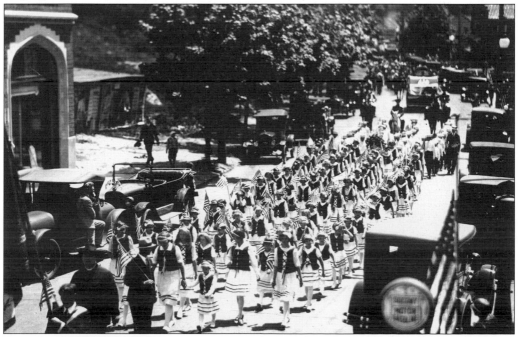

PARADE, C. 1929. The Polish community members made a grand showing as they marched up Glen Street in full folk costume in the Memorial Day parade. The year 2007 marked the 85th anniversary of the founding of the Polish National Home. (Courtesy Polish National Home.)

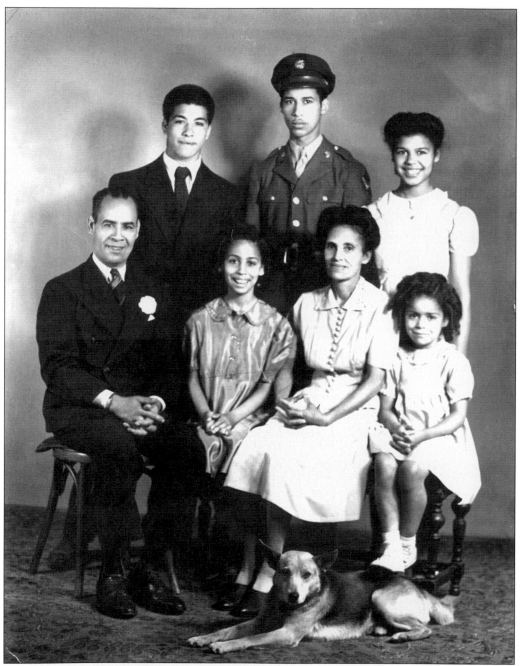

THE ORTIZ FAMILY, C. 1945. The Ortiz family put down roots in Glen Cove in 1919 when Rosaura Ortiz came from Puerto Rico to work as a laundress on the Appleby estate. Her family followed. Pictured are, from left to right, Pal the dog; (first row) Thomas, Rose, Rosaura, and Mercedes; (second row) Victor, Tommy, and Marg Ortiz. The photograph was taken before Tommy left to serve in the Pacific theater during World War II. In the 1950s, the Puerto Rican community in Glen Cove grew, attracted by economic opportunities offered by expanding industries. (Courtesy Mercedes Morales.)

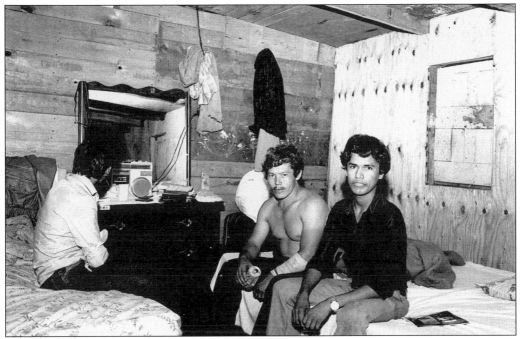

SALVADORAN REFUGEES, 1986. In the 1980s, the civil war in El Salvador forced vast numbers of its citizens to flee for political and economic reasons. A large community of Central Americans settled in Glen Cove. This fast-growing segment of the population is served by La Fuerza Unida, begun in 1978 to look after the interests of the Latino community. (Courtesy Michael E. Ach.)

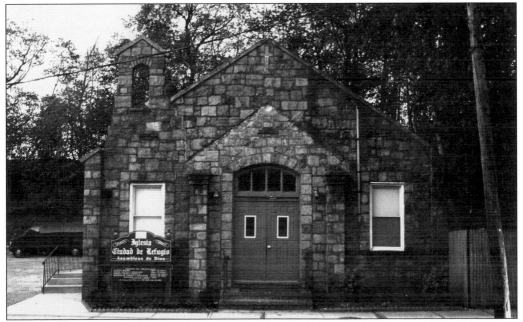

PENTECOSTAL CHURCHES. Churches like Iglesia Ciudad de Refugio Assembleas de Dios, a Pentecostal church on Cottage Row, take care of the hearts and souls of the newest immigrants. Other Pentecostal churches meet in the Methodist church and have even met in the movie theater.

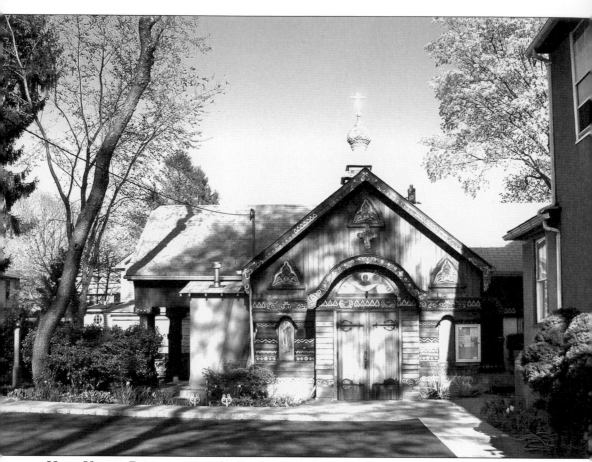

HOLY VIRGIN PROTECTION AND ST. SERGIUS RUSSIAN ORTHODOX CHURCH. Consecrated Holy Virgin Protection on November 26, 1951, by His Eminence Metropolitan Anastassy, this hand-carved wooden church is located next to a former Russian old age home on Alvin Street. Holy Virgin Protection parish was joined by St. Sergius Russian Orthodox's parish after the closing of the cathedral on Old Tappan Road, and a new church hall was built on the grounds.

Seven

THE ORCHARD

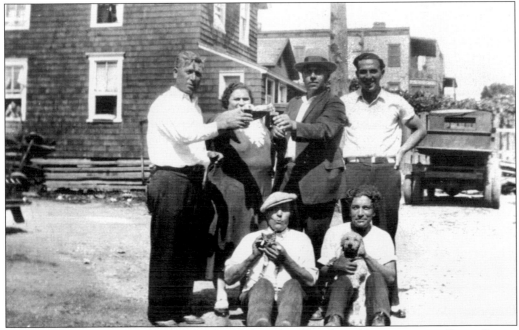

GROVE STREET, C. 1937. Members of the Carbuto family and neighbors cavort on Grove Street. The Orchard was once a complete Italian village within a seven-block triangle. The backyards were miniature farms complete with goats, pigs, and chickens and lush gardens of tomatoes, basil, grapes, and figs. The area had its own butchers, bakers, restaurants, hairdressers, and a favorite candy store with a potbellied stove. Most residents emigrated from the town of Sturno, in the Province of Avellino in the Campania region or from the region of Calabria. (Courtesy Ester Carbuto.)

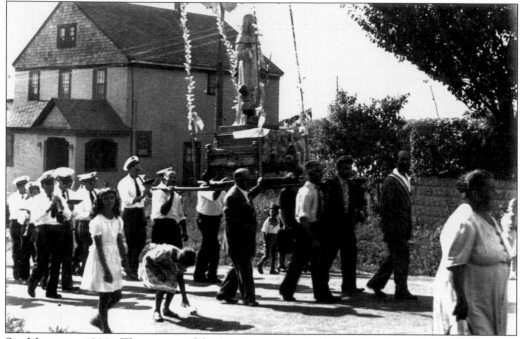

ST. MARINA, 1933. The statue of St. Marina was carried from Dominick Bellissimo's house on First Street through the neighborhood to her new home in St. Rocco's Chapel. In 1922, immigrants from Calabria started a mutual aid society and *una piccola festa* in honor of their patron, St. Marina. Land the society acquired was later seceded to the new Italian parish for the building of St. Rocco's Church. (Courtesy Ester Carbuto.)

ST. ROCCO'S CHAPEL, 1935. The Italians in Glen Cove fervently wanted their own parish and an Italian pastor. The St. Marina Society and St. Rocco Society pooled resources to build La Cappella, a small wooden chapel. Angelo Cocchiola led the petition for the establishment of an Italian parish and succeeded in his goal through the intercession of Cardinal Eugenio Pacelli, who later became Pope Pius XII. (Courtesy Ester Carbuto.)

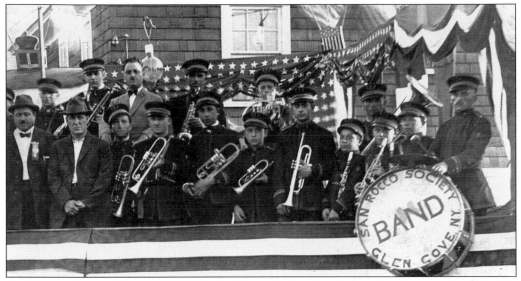

St. Rocco Society Band, 1937. The St. Rocco Society Band played at the groundbreaking for the church. Gabe Cocchiola, the youngest musician in the 40-member group, can be seen to the left of the drum. The society itself was chartered in 1910 under the leadership of Angelo. The St. Rocco Society was a mutual aid organization that assisted members in adversity and illness and helped with burial expenses when necessary. It also sponsored the annual St. Rocco's Feast. (Courtesy Cocchiola family.)

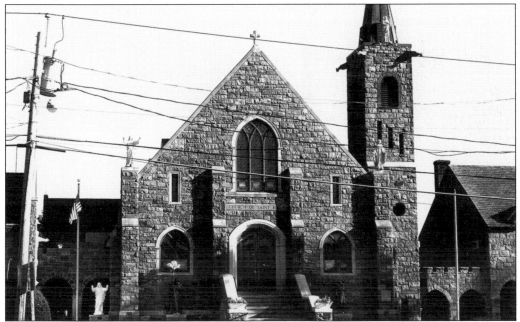

St. Rocco's Church. Michael Pascucci was just 26 years old and an architecture student at Pratt Institute when Fr. Eliodoro Capobianco, the first pastor, asked him to design the church. Everyone in the community pledged their skills, and a team of local masons, bricklayers, and carpenters built the church with their love and bare hands. Ground was broken in July 1937, and the church was finished in time for a joyously tearful midnight mass on Christmas Eve the same year.

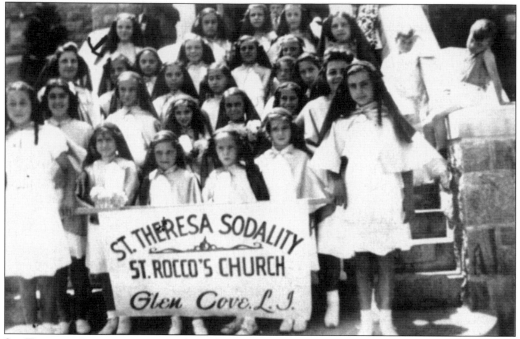

ST. THERESA SODALITY, 1938. This religious group for young girls gathered on the steps of the newly built church to have their picture taken. The members of the sodality expressed their religious devotion through prayer and good deed. (Courtesy Marion O'Day.)

ST. ROCCO'S PROCESSION, 1981. Fr. Eligio Della Rosa lead the faithful in a procession through the neighborhood that brought the statue of St. Rocco to the homes of the sick and housebound. This religious pageant is the culmination of a weeklong carnival that takes place each July. In 1975, Father Della Rosa revitalized the parish and resurrected the feast, which was celebrated only sporadically after World War II.

ON BELLA VISTA STREET, 1981. St Rocco's procession continued past Gabe's Deli on Bella Vista Street and back toward the church. Often as many as a thousand people come to pray, pin money on the ribbons decorating the St. Rocco statue, and eat Italian delicacies at the "Best Feast in the East."

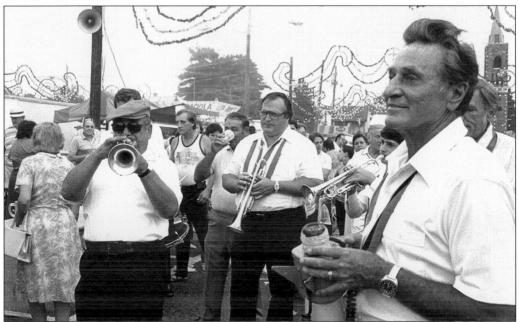

STROLLING BAND AT THE FEAST, 1983. From left to right, Felix Sangenito (on trumpet), an unidentified band member, and Alfred Carbuto play music and sing Italian songs as they stroll about St. Rocco's Feast. These musicians were loved and respected by generations of village children whom they taught to play instruments.

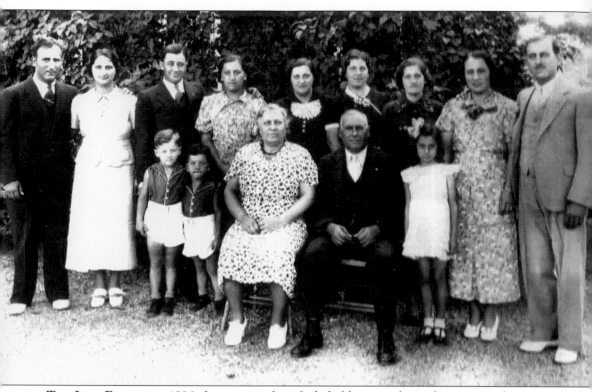

THE IZZO FAMILY, C. 1930. Immigrants from Italy held many jobs in the process of orienting themselves to America. Domenica Izzo was a landscaper, coachman, chauffeur, and bicycle repairman before he opened a grocery store on the corner of First Street and Cedar Swamp Road. He and his wife, Ursula, originally from Sturno, Italy, raised their large family in their home behind the store. By 1940, Izzo was a successful self-employed builder/contractor. (Courtesy Kent Quackenbush.)

THE NEIGHBORHOOD, 1920s. The Orchard in the early days is remembered as both paradise and as an overcrowded slum with no sanitation and rampant disease. New immigrants boarded in the homes of the more established, and their rents helped to pay the mortgages. The community grew and prospered until the neighborhood spread across Cedar Swamp Road to East Avenue and from Elm Avenue to Fourth Street. (Courtesy Cocchiola family.)

Top Row-Doorway: Mrs. Sanfrantello,son;Carmella Stango
Baby sister Virginia-Mrs. Carmella Capobianco-Mrs. Fabiano
Danny Pardoes Grandmother

Kids on the curb:Madurno girls- Gabe Cocchiola

ORCHARD HOUSE DINNER, 1937. The Annual Circolo Generale Graziani Dinner was held at the Orchard House on Hazel Street. The settlement house, organized by the wealthy for new immigrants, looked out for the social welfare of the neighborhood. It had a kindergarten and offered cooking, dramatics, and sewing classes. Long Island's first Order of the Sons of Italy Loggia 1016 formed here in 1920. Orchard House stood on the site of Stango's restaurant parking lot.

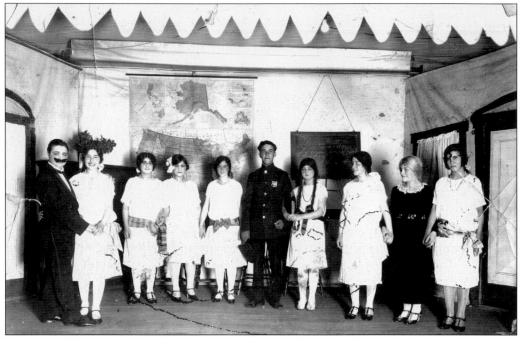

ORCHARD HOUSE PLAY, C. 1927. The Merry Maids put on dramatic presentations at the Orchard House in the 1920s. Among the actors are Annie DiGiovanni (third from left), who celebrated her 99th birthday on October 6, 2007. Talented at needlecraft and frustrated by the way the local shops were run, DiGiovanni set up her own rug-making business in the Orchard behind her father's barbershop and employed her friends. (Courtesy Ester Carbuto.)

THE MERRY MAIDS, C. 2000. The Merry Maids, a club for girls originally sponsored by the Orchard House, still meets on occasion. At the left side of the Maids table in Stango's restaurant, Jenny Sanfratello stands behind Stella Cocchiola, whose parents founded this neighborhood institution in 1919. (Courtesy Jenny Sanfratello.)

STANGO'S, C. 1947. After World War II, Gabe Cocchiola, Eddie Graziosi, Jean Miller, and Susan Stango Wingate with her aunt Stella Cocciola pose at the bar. Stango's restaurant has been in continuous operation since its founding in 1919 by Frank and Concetta Stango. In the early days, there was no menu, but the clientele who boarded in the neighborhood found comfort in the homemade meals served there. Today Stella still presides over the dining room with her sons, Gabe and John, behind the bar. (Courtesy Susan Stango Wingate.)

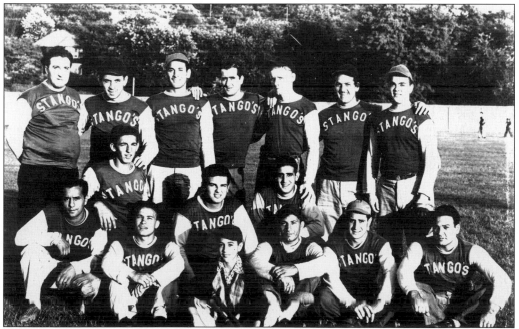

STANGO'S BALL TEAM, 1947. In the 1940s, Stango's sponsored a neighborhood ball team that played in the Glen Cove City League. The team poses in uniform with the batboy. Other neighborhood athletes played basketball for the Orchard House, known to have a court with the lowest ceilings in the city. (Courtesy Cocchiola family.)

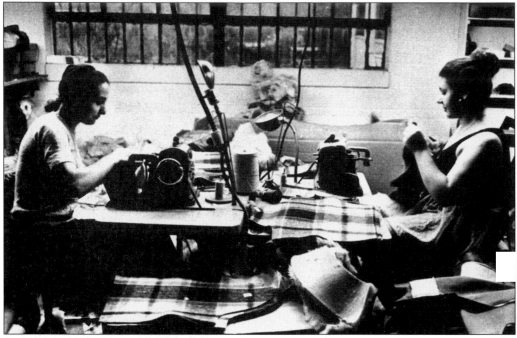

THE SHIRT FACTORY, 1978. Women gossip and sew at Hymie Frank's Shirt Factory on Hazel Street. Many girls finished school and went to work in the factory at 16. Children of married women were cared for at the Orchard House. The shirt factory was just one workshop in Glen Cove's "Little Italy" garment industry. (Courtesy Lucinda Carbuto Geist.)

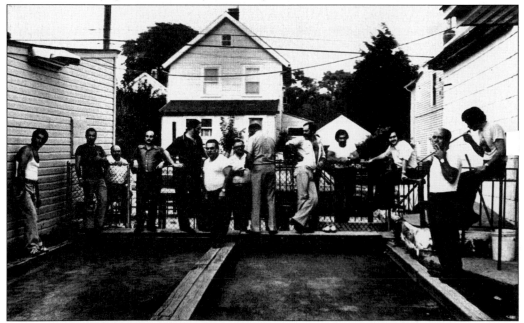

BOCCE COURT, 1978. On summer nights, the bocce court, outside of DeLuca's bar, was the central gathering place for the men of the community to meet and talk while showing off their skills. The pastime is undergoing a revival due to the recent renovation of the court. (Courtesy Lucinda Carbuto Geist.)

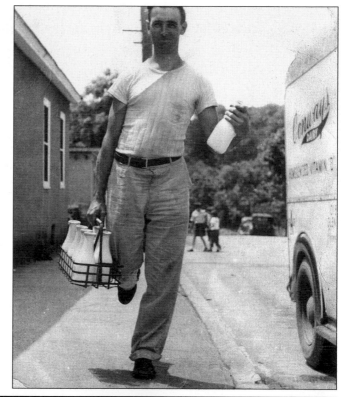

MILK DELIVERY, AUGUST 10, 1950. Herbert Conway delivers milk from his family farm to the residents of Grove Street. The four-acre Conway Farm was located on Elm Avenue. Today the 160-year-old farmhouse stands, but the barn and 15 cows have given way to the houses of Conway Court. (Courtesy Herbert Conway.)

SALVATORE BASILE, 1978. On the occasion of Salvatore Basile's 60th wedding anniversary celebration, Paul Pennoyer, the grandson of J. P. Morgan, and his wife, Cecily, present Basile with a painting of Round Bush, their estate, which he cultivated for more than 65 years. Basile and his wife, Francesca, who married him at 12 and gave birth to 16 children, raised their family on Grove Street. (Courtesy Vincent Basile.)

THE FOUR MAYORS SUOZZI, c. 2000. The Suozzi family has had a major influence over the development and governance of the city of Glen Cove. Seen here are, from left to right, beloved Mayor Vincent "Jimmy" Suozzi, who was elected to office five times, presided over the urban renewal of the city, and started Glen Cove's sister city relationship with Sturno, Italy; his son Ralph Suozzi, the present mayor, who is currently developing a master plan for the transformation of Glen Cove into a 21st-century city; Thomas Suozzi, Ralph's cousin, four-term mayor and two-term Nassau County executive, who is the youngest official ever elected to either office; and Joseph A. Suozzi, father of Tom Suozzi, who was the mayor from 1956 to 1960 and was the youngest judge ever elected to the Appellate Division of the New York State Supreme Court. Joseph and Vincent Suozzi were the sons of Michele Suozzi, a worker on the Gold Coast Estates who was a major advocate for the early Italian community.

Eight

RENEWAL AND REVITALIZATION

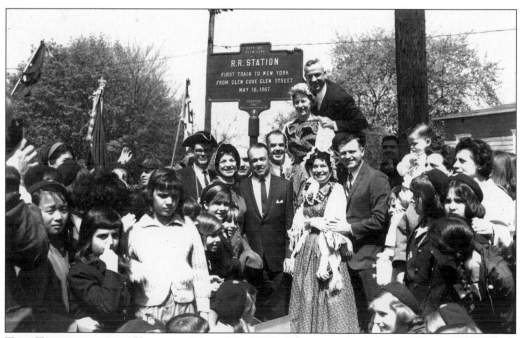

THE TERCENTENNIAL KICKOFF, MAY 16, 1968. The arrival of the 10:15 a.m. train from Jamaica marked the 100th anniversary of railroad coming to Glen Cove. In addition to a Girl Scout troop, from left to right among the crowd are historian Peter Van Santvoord (in tricorn hat), Juanita Carroll, James Schultz, state senator Henry M. Curran, Eleanor Brighton, and assemblyman Joseph Reilly. Mayor Joseph Muldoon and chairperson of the tercentennial committee Maggie Polk are next to the historical marker commemorating the occasion. This event at the Glen Street station started the beginning of a yearlong celebration of the 300th anniversary of the founding of Musketa Cove, the 50th anniversary of the establishment of the city, and the commencement of major urban renewal.

MILLER HOMES, 1957. The newly built Miller Homes on Phillips Drive sold for $12,000 in 1957. The 1950s saw large portions of the countryside and farmland around the city turned into housing developments. These former Pratt lands were the town victory gardens during World War II. (Courtesy Walter J. Paddison.)

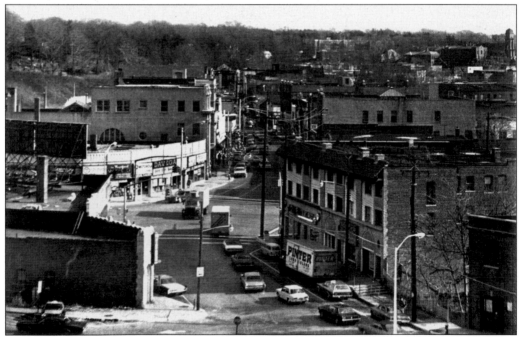

WEST GLEN STREET, C. 1970. John Beatty documented West Glen Street just before the building of Village Square Shopping Center during the urban renewal project. West Glen Street, which no longer exists, housed two Jewish bakeries and two kosher butcher shops.

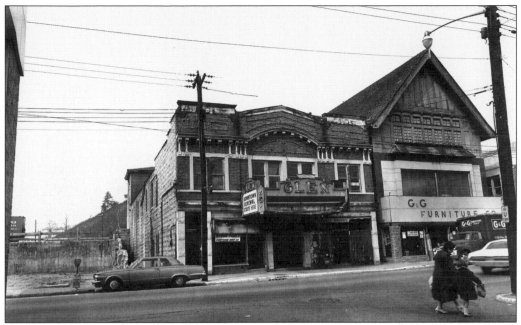

GLEN THEATRE AND G&G, C. 1972. The Glen Theatre was demolished for the building of the entrance to the Pulaski Street parking garage. The old post office building to its right, the G&G Furniture store for many years, has been restored to its former glory and is currently an architect's office.

CANNER'S, C. 1960. Canner's fabrics and notions has served the community for three generations. Joseph Canner started the business on Glen Street after quitting his job as foreman of a shirt factory. Today granddaughter Robin Dando manages the busy shop located off Forest Avenue. (Courtesy Canner family.)

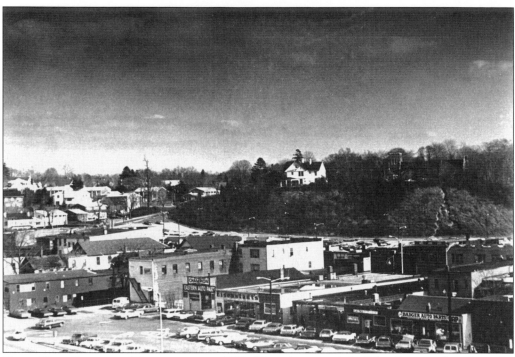

TOWN VIEW LOOKING NORTHEAST, C. 1970. This photograph by John Beatty, taken from the western hill, looks across School Street and the valley toward the Seaman house on Highland Road. Mayor William H. Seaman's home was, for many years, an important focal point of the village. Today Highland Mews, a private community, occupies the property.

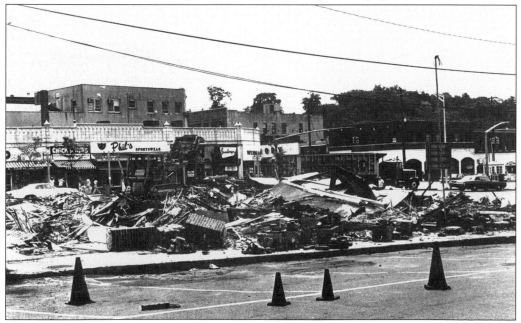

SCHOOL STREET DEMOLITION, C. 1974. During urban renewal in the 1970s, the western side of School Street was leveled. The demolition was delayed for a long time by businesses that objected to the razing of School Street and refused to move.

TOWN VIEW LOOKING SOUTHEAST,
c. 1973. A young boy and his dogs
stand on the hill in this view looking
southeast across the city. The Glen
Theatre has been demolished, but
the Pulaski Street garage has not
been built yet. The 1970s saw the
start of the "Breakfast Program" and
the "School of Tomorrow," social and
educational programs meant to give
disadvantaged youth a better chance
in life. (Courtesy Michael E. Ach.)

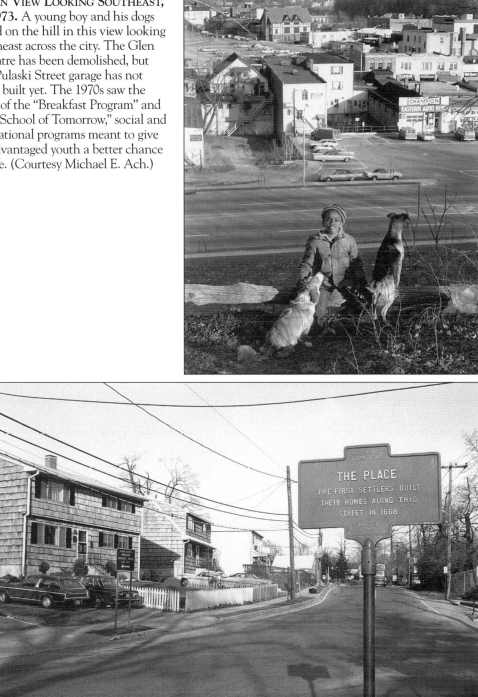

THE PLACE, 1973. During urban renewal, moderate- and low-income homes replaced the old
Mudge farm and filled the "Home Lotts" of the first settlers on the Place. Today this area, the
oldest in the city, is slated for demolition and will be rebuilt as a town house complex. (Courtesy
Michael E. Ach.)

JAMES DAVIS, CIVIL RIGHTS LEADER, EARLY 1960S. James Davis was a major force behind the civil rights movement in Glen Cove. A mechanic for American Airways, he is shown (on the left) visiting daughter Sheryl's class during career day at South School. Sheryl Davis (Goodine), plaintiff in the case to desegregate Glen Cove schools, is the assistant principal of the high school. On the right, Davis shows the shoes he wore out and his jacket that was spat on during his march through the South with Dr. Martin Luther King. (Courtesy Sheryl Davis Goodine.)

JANET LANE, C. 1973. These 54 units of low- to middle-income housing replaced the old Dickson-Prince House. They were built through the efforts of Davis, who was instrumental in passing open housing laws in both the city of Glen Cove and Nassau County. (Courtesy Michael E. Ach.)

THE CREEK, 1991. In March 1998, Vice Pres. Al Gore announced that the city of Glen Cove had been selected as a National Brownfield's Showcase Community. Serious environmental cleanup of the factory creek and environs began, and plans were put forth for development of a "seaport village in harmony with the natural environment." Today the area has been remediated, and a newly clean harbor should open to shell fishing by 2010.

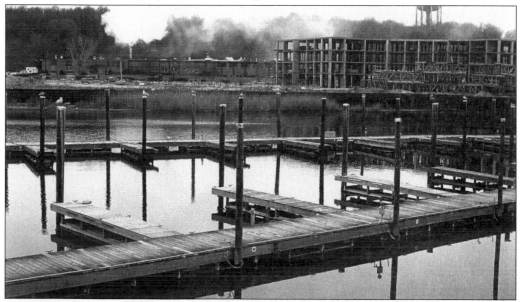

CAPTAIN'S COVE, C. 1980. Efforts to redevelop the Captain's Cove property were abandoned in the mid-1980s, when the New York State Department of Environmental Conservation designated the area a New York State Superfund site. From 1960 on, the land was a dump site for incinerator ash, sewage sludge, household debris, creek sediments, and industrial waste. Today the area has been cleaned up, and redevelopment is again in the planning stages. (Courtesy Michael E. Ach.)

LI TUNGSTEN STACK, 1998. On Earth Day, April 22, 1998, Mayor Thomas Suozzi demolished the Li Tungsten stack in a dramatic public detonation, signifying the end of the industrial era and the start of waterfront cleanup of the superfund sites. Wah Chang/Li Tungsten was the major supplier of tungsten to the Allies during World War II. (Courtesy Michele Kutner.)

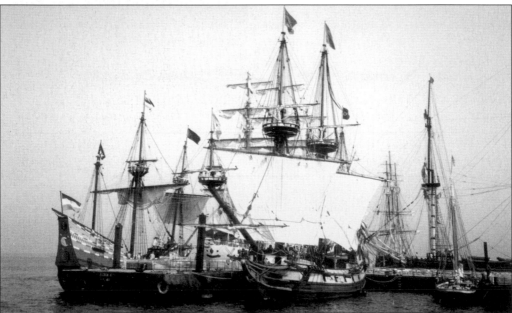

AMERICA'S SAIL, 1998. In a gala that outdid the bicentennials and tercentennials, all Glen Cove and most of Long Island turned out for a six-day festival that started with a coastal race of Class A tall ships from Savannah to Glen Cove. Ships at anchor in the harbor included the *Simon Bolivar* from Venezuela, the Argentine *Libertad*, the HMS *Bounty*, the *Kalmar Nyckel*, the *Half Moon*, and the *Clearwater*.

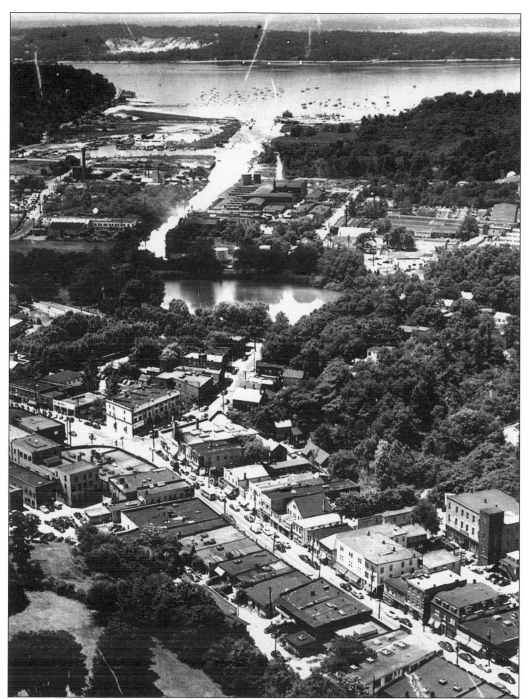

AERIAL VIEW OF GLEN COVE, C. 1949. The landscape and demographics of the city of Glen Cove are in a continual process of change and evolution. As the end of the first decade of the new millennium draws to a close, the city is in the process of redefining itself. Under enormous pressure for development, only time will tell if the Gold Coast will continue to shine as a suburban jewel or begin to glitter as a metropolis of glass and steel. (Courtesy Michele Kutner.)

ACROSS AMERICA, PEOPLE ARE DISCOVERING SOMETHING WONDERFUL. *THEIR HERITAGE.*

Arcadia Publishing is the leading local history publisher in the United States. With more than 3,000 titles in print and hundreds of new titles released every year, Arcadia has extensive specialized experience chronicling the history of communities and celebrating America's hidden stories, bringing to life the people, places, and events from the past. To discover the history of other communities across the nation, please visit:

www.arcadiapublishing.com

Customized search tools allow you to find regional history books about the town where you grew up, the cities where your friends and family live, the town where your parents met, or even that retirement spot you've been dreaming about.